P9-AUj-214

hairspray

Book by **MARK O'DONNELL** and **THOMAS MEEHAN**
Music by **MARC SHAIMAN**
Lyrics by **SCOTT WITTMAN** and **MARC SHAIMAN**

Based on the New Line Cinema film written and directed by **JOHN WATERS**
Production photos by Paul Kolnik

APPLAUSE
THEATRE & CINEMA BOOKS

Hairspray
Book by **MARK O'DONNELL** and **THOMAS MEEHAN**
Music by **MARC SHAIMAN**
Lyrics by **SCOTT WITTMAN** and **MARC SHAIMAN**

Library of Congress Control Number: 2003102321

British Library Cataloging-in-Publication Data
 A catalog record for this book is available from the British Library

ISBN: 1-55783-514-4

Applause Theatre & Cinema Books
19 West 21st Street
Suite 201
New York, NY 10010
Phone: (212) 575-9265
Fax: (212) 575-9270
Email: info@applausepub.com
Internet: www.applausepub.com

Piano/vocal selections from *Hairspray* also available from Hal Leonard Corporation:
www.halleonard.com
Inventory #HL00313219

SALES & DISTRIBUTION

North America:
HAL LEONARD CORP.
7777 West Bluemound Road
P.O. Box 13819
Milwaukee, WI 53213
Phone: (414) 774-3630
Fax: (414) 774-3259
Email: halinfo@halleonard.com
Internet: www.halleonard.com

EUROPE:
ROUNDHOUSE PUBLISHING LTD.
Millstone, Limer's Lane
Northam, North Devon EX 39 2RG
Phone: (0) 1237-474-474
Fax: (0) 1237-474-774
Email: roundhouse.group@ukgateway.net

PRODUCED ON BROADWAY BY
Margo Lion
Adam Epstein
The Baruch-Viertel-Routh-Frankel Group
James D. Stern/Douglas L. Meyer
Rick Steiner/Frederic H. Mayerson
SEL & GFO
New Line Cinema

IN ASSOCIATION WITH
Clear Channel Entertainment
A. Gordon/E. McAllister
D. Harris/M. Swinsky
J. & B. Osher

The world premiere of *Hairspray* was produced with
the 5th Avenue Theatre in Seattle, Washington

David Armstrong, Producing Artistic Director;
Marilynn Sheldon, Managing Director

CONTENTS

THE CAST

(in order of appearance)

Tracy Turnblad	**MARISSA JARET WINOKUR**
Corny Collins	**CLARKE THORELL**
Amber Von Tussle	**LAURA BELL BUNDY**
Brad	**PETER MATTHEW SMITH**
Tammy	**HOLLIE HOWARD**
Fender	**JOHN HILL**
Brenda	**JENNIFER GAMBATESE**
Sketch	**ADAM FLEMING**
Shelley	**SHOSHANA BEAN**
IQ	**TODD MICHEL SMITH**
Lou Ann	**KATHARINE LEONARD**
Link Larkin	**MATTHEW MORRISON**
Prudy Pingleton	**JACKIE HOFFMAN**
Edna Turnblad	**HARVEY FIERSTEIN**
Penny Pingleton	**KERRY BUTLER**
Velma Von Tussle	**LINDA HART**
Harriman F. Spritzer	**JOEL VIG**
Wilbur Turnblad	**DICK LATESSA**
Principal	**JOEL VIG**
Seaweed J. Stubbs	**COREY REYNOLDS**
Duane	**ERIC ANTHONY**
Gilbert	**ERIC DYSART**
Lorraine	**DANIELLE LEE GREAVES**
Thad	**RASHAD NAYLOR**
The Dynamites	**KAMILAH MARTIN, JUDINE RICHARD, SHAYNA STEELE**
Mr. Pinky	**JOEL VIG**
Gym Teacher	**JACKIE HOFFMAN**
Little Inez	**DANELLE EUGENIA WILSON**
Motormouth Maybelle	**MARY BOND DAVIS**
Matron	**JACKIE HOFFMAN**
Guard	**JOEL VIG**
Cindy	**JUDINE RICHARD**
Swings	**JOSHUA BERGASSE, GREG GRAHAM, BROOKE TANSLEY**

Denizens of Baltimore:
Eric Anthony, Shoshana Bean, Eric Dysart, Adam Fleming, Jennifer Gambatese, Danielle Lee Greaves, David Greenspan, Katy Grenfell, John Hill, Jackie Hoffman, Hollie Howard, Katharine Leonard, Kamilah Martin, Rashad Naylor, Judine Richard, Peter Matthew Smith, Todd Michel Smith, Shayna Steele, Joel Vig

BROADWAY SHOW
CAST AND CREDITS

The world premiere of *Hairspray* was produced with the 5th Avenue Theatre in Seattle, Washington; with David Armstrong as Producing Artistic Director and Marilynn Sheldon as Managing Director.

Its Broadway premiere was at the Neil Simon Theatre on August 15, 2002.

It was produced on Broadway by Margo Lion, Adam Epstein, The Baruch-Viertel-Routh-Frankel Group, James D. Stern/Douglas L. Meyer, Rick Steiner/Frederic H. Mayerson, SEL & GFO, and New Line Cinema in association with Clear Channel Entertainment, A. Gordon/E. McAllister, D. Harris/M. Swinsky, and J. & B. Osher

Book	MARK O'DONNELL
	and THOMAS MEEHAN
Music	MARC SHAIMAN
Lyrics	SCOTT WITTMAN and MARC SHAIMAN
Director	JACK O'BRIEN
Choreographer	JERRY MITCHELL
Set Designer	DAVID ROCKWELL
Costume Designer	WILLIAM IVEY LONG
Lighting Designer	KENNETH POSNER
Sound Designer	STEVE C. KENNEDY
Casting	BERNARD TELSEY CASTING
Production Supervisor	STEVEN BECKLER
Wigs and Hair Designer	PAUL HUNTLEY
Orchestrations	HAROLD WHEELER
Music Director	LON HOYT
Arrangements	MARC SHAIMAN
Music Coordinator	JOHN MILLER
General Management	RICHARD FRANKEL PRODUCTIONS
	and LAURA GREEN
Technical Supervision	TECH PRODUCTION SERVICES, INC
Press Representatives	RICHARD KORNBERG and DON SUMMA
Associate Producers	RHODA MAYERSON,
	THE ASPEN GROUP, and DANIEL C. STATON

Based on the motion picture released by New Line Cinema,
written and directed by John Waters.

number) for "The Academy Awards" as well as a nomination for *Saturday Night Live*. Mr. Shaiman has been nominated for two Grammy Awards for his work with Harry Connick, Jr., and has been awarded numerous gold and platinum records. He has written the music, lyrics, arrangements, and compositions for numerous Off-Broadway musicals. He lives in New York City and Los Angeles.

SCOTT WITTMAN conceived and directed Patti LuPone's Carnegie Hall debut as well as her hit solo shows, *Matters of the Heart* and *Patti LuPone on Broadway* (Outer Critics Circle Award). He co-wrote the musicals *The G-String Murders*, *Trilogy of Terror*, and *Livin' Dolls* and directed the west coast premiere of the musical *Eating Raoul* as well as the L.A. production of *Livin' Dolls* for which he received both the Dramalogue and *L.A. Weekly* awards for best director. Off-Broadway he directed *Broadway '68*, a hit revue of songs from that season's worst musicals at La MaMa; revues of Marc Shaiman's theatre songs, and re-interpretations of such classics as *The Sound of Music*, starring Holly Woodlawn; *Peter Pan*, starring John Sex; and *The Trojan Women*. Mr. Wittman directed an all-star cast, including Bette Midler, Elaine Stritch, Madeline Kahn, and Lypsinka, in *Doin' What Comes Natr'lly*, a benefit tribute to Ethel Merman. For PBS, he directed Sarah Jessica Parker and Nathan Lane in solo performances with the Boston Pops. Other television credits include serving as writer and segment producer for *The Howard Stern Show* and co-writing special music material for *The Martin Short Show*. He lives in New York City and Los Angeles.

AUTHOR AND LYRICIST BIOGRAPHIES

MARK O'DONNELL's plays include *That's It, Folks!, Fables for Friends*, and *The Nice and the Nasty* (all produced at Playwrights Horizons), and *Strangers on Earth* and *Vertigo Park* (both produced by Zena Group Theatre). He wrote the book and lyrics for the musical *Tots in Tinseltown*. He collaborated with Bill Irwin on an adaptation of Moliere's *Scapin* and he co-authored a translation of Feydeau's *A Flea in Her Ear*, both for the Roundabout. For Manhattan Theatre Club he translated Jean Claude Carriere's *La Terrasse*. Mr. O'Donnell's one-act plays are widely produced, most notably at Actors Theatre of Louisville. He has published two collections of comic stories, *Elementary Education* and *Vertigo Park and Other Tall Tales*, as well as two recent novels *Getting Over Homer* and *Let Nothing You Dismay*. His humor, cartoons, and poetry have appeared in *The New Yorker, The New York Times, The Atlantic, Spy, The New Republic*, and *Esquire*, among many others. He lives in New York City.

THOMAS MEEHAN won the 2001 Tony Award for co-writing the book for *The Producers*, the new Mel Brooks musical. He received his first Tony Award in 1977 for writing the book of *Annie*, which was his first Broadway show, and has since written the books for the musicals *I Remember Mama, Ain't Broadway Grand*, and *Annie Warbucks*. In addition, he is a longtime contributor of humor to *The New Yorker*, an Emmy Award–winning writer of television comedy, and a collaborator on a number of screenplays, including Mel Brooks' *Spaceballs* and *To Be or Not to Be*. He lives in New York City and Nantucket, Massachusetts.

MARC SHAIMAN won the 2003 Grammy Award for Best Musical Show Album, for *Hairspray*. He has worked on or appeared in over 50 films and has been nominated for five Academy Awards for *The First Wives Club, Sleepless in Seattle, Patch Adams, The American President*, and the animated musical, *South Park: Bigger, Longer & Uncut*. His other film credits include *A Few Good Men, Sister Act, City Slickers, The Addams Family, Misery, When Harry Met Sally..., Beaches, Mother, George of the Jungle, In & Out, The Story of Us* (with Eric Clapton), and *Marci X*. He was Bette Midler's musical director and co-producer, bringing her songs like the Grammy-winning "Wind Beneath My Wings" and "From A Distance" and collaborating with her on her Emmy Award-winning performance for the final *Tonight Show with Johnny Carson*. For television, Mr. Shaiman has worked on HBO's *From the Earth to the Moon* and *61** and received an Emmy Award for writing (Billy Crystal's opening

CHARACTERS

TRACY TURNBLAD A high-spirited, irrepressible, chubby teen girl; she loves to dance and is eager for her life to kick in

EDNA TURNBLAD Her hefty, loving, somewhat repressed mother, a laundress with deferred dreams

WILBUR TURNBLAD Tracy's father, a mischievous joke shop proprietor but always reliable dad

PENNY PINGLETON Tracy's ditzy but devoted best friend

CORNY COLLINS The smooth and smart adult host of Baltimore's local TV teen dance show

LINK LARKIN The show's teen male dreamboat, ambitious but essentially good-hearted

AMBER VON TUSSLE The show's resident princess, conniving and selfish, but superficially perky

VELMA VON TUSSLE The TV station manager; a rich, bigoted, bossy widow who's pushing daughter Amber to the stardom she herself never had

MOTORMOUTH MAYBELLE The big, brassy, all-embracing black radio DJ and once-a-month guest host on Corny's show; she wears blonde wigs as her trademark

SEAWEED J. STUBBS Her sexy teen son, street smart but easygoing; his unique dance lessons give Tracy the edge she needs to catch Corny's attention

LITTLE INEZ Seaweed's little sister, 12. She's cute but angry, impatient for the promised land of actual civil rights

MALE AUTHORITY FIGURE One man plays assorted middle-aged men: a nervous businessman, a condescending high school

principal, a flamboyant fashion boutique owner, a cop, and a corrupt jail guard

FEMALE AUTHORITY FIGURE One woman plays assorted middle-aged women: Prudy (Penny's incredibly uptight and small-minded mother), a sadistic gym teacher, a cop, and a sardonic prison matron

THE DYNAMITES A trio of ultra-glamorous black divas who emerge from a poster to be the magical hostesses of Tracy and Edna's whirlwind visit to the emerging Swinging Sixties

THE COUNCIL MEMBERS

PATTERSON PARK HIGH SCHOOL STUDENTS

DENIZENS OF BALTIMORE

MUSICAL NUMBERS

ACT ONE

"Good Morning Baltimore" — TRACY & COMPANY

"The Nicest Kids in Town" — CORNY COLLINS & COMPANY

"(Mama) I'm a Big Girl Now" — EDNA, TRACY, PRUDY, PENNY, VELMA, AMBER, & COMPANY

"I Can Hear the Bells" — TRACY & COMPANY

"(The Legend of) Miss Baltimore Crabs" — VELMA

"Nicest Kids in Town" (reprise) — CORNY COLLINS & COMPANY

"It Takes Two" — LINK, TRACY, & MEN

"Velma's Revenge" — VELMA

"Welcome to the '60s" — TRACY, EDNA, & COMPANY

"Run and Tell That!" — SEAWEED, LITTLE INEZ, & COMPANY

"Big, Blonde, & Beautiful" — MOTORMOUTH, TRACY, EDNA, & COMPANY

ACT TWO

"The Big Dollhouse" — WOMEN

"Good Morning Baltimore" (reprise) — TRACY

"(You're) Timeless to Me" — EDNA & WILBUR

"Without Love" — TRACY, LINK, PENNY, SEAWEED, & COMPANY

"I Know Where I've Been" — MOTORMOUTH & COMPANY

"(It's) Hairspray" — CORNY & COMPANY

"Cooties" — AMBER & COUNCIL MEMBERS

"You Can't Stop the Beat" (part 1) — FULL COMPANY

"You Can't Stop the Beat" (part 2) — FULL COMPANY

hairspray

ACT ONE

PROLOGUE

(*The* CURTAIN *rises on* TRACY TURNBLAD *in her bed. The time is around* 7AM *on a Monday morning in early June of 1962.*)

"Good Morning Baltimore"

TRACY
Oh, oh, oh
Woke up today
Feeling the way I always do
Oh, oh, oh
Hungry for something that I can't eat
Then I hear the beat

That rhythm of town
Starts calling me down
It's like a message from high above
Oh, oh, oh
Pulling me out
To the smiles and the streets
 that I love

	BACKUP
Good morning Baltimore	Good morning Baltimore
Every day's like an open door	
	Aah-aah...
Every night is a fantasy	Fantasy
Every sound's like a symphony	
Good morning Baltimore	Good morning Baltimore
And some day	
When I take to the floor	Ooh-ooh
The world's gonna wake up and see	Aah-see-ee
Baltimore and me	

TRACY (continued)	**BACKUP** (continued)
Oh, oh, oh	Hoot
Look at my hair	Hoo-oot
What 'do can compare	
With mine today?	...Mine today
Oh, oh, oh	Hoot
I've got hairspray and radio	
I'm ready to go	...Ready to go
The rats on the street	Ooh-ooh
All dance 'round my feet	Ooh-ooh
They seem to say	Ooh
Tracy, it's up to you	...up to you
So, oh, oh	
Don't hold me back	
'Cause today	...Today
All my dreams will come true	All my dreams will come true
Good morning Baltimore	Good morning Baltimore
There's the flasher	
Who lives next door	Aah-aah
There's the bum	
On his bar room stool	...Bar room stool
They wish me luck on my way	
to school	
Good morning Baltimore	Good morning Baltimore
And some day	
When I take to the floor	Ooh-ooh
The world's gonna wake up and see	Wah... see
Baltimore and me	
I know every step	Hoot
	Hoo-oot
I know every song	
	Hoo-oot

O'Donnell, Meehan, Shaiman, and Wittman

TRACY (continued)
I know there's a place
Where I belong

I see all the party lights
Shining ahead

So someone invite me
Before I drop dead

So, oh, oh
Give me a chance
'Cause when I start to dance

I'm a movie star

Oh, oh, oh
Something inside of me
Makes me move
When I hear that groove

My Ma tells me no,
But my feet tell me go
It's like a drummer
Inside my heart

Oh, oh, oh
Don't make me wait
One more moment
For my life to start

I love you Baltimore
Every day's like an open door
Every night is a fantasy
Every sound's like a symphony

BACKUP (continued)
Where I belong

Hoot
Hoo-oot

Before she drops dead
Ooh
Ooh-ooh

Movie star

Ooh-ooh

Makes me move
When I hear that groove

Ooh-ooh
Ooh-ooh
Ooh
... 'Side my heart

One more moment
For my life to start

Good morning
Good morning
Waiting for my life to start
I love you Baltimore

Aah-aah... fantasy

TRACY (continued)
And I promise Baltimore
That some day
When I take to the floor
The world's gonna wake up and see
Gonna wake up and see
Baltimore and me

Baltimore and me...

Baltimore and me...

BACKUP (continued)
I promise Baltimore

Take to the floor
Wah... see
Gonna wake up and see

Yes, more or less we all agree

Someday the world is
 gonna see
...And me...

O'Donnell, Meehan, Shaiman, and Wittman

SCENE ONE

*(TV Station WZZT and the TURNBLAD home
simultaneously. Monday afternoon.)*

"The Nicest Kids in Town"

CORNY

Hey there, Teenage Baltimore!
Don't change that channel! 'Cause
it's time for *The Corny Collins
Show*! Brought to you by Ultra
Clutch Hairspray! For hair that
holds up even in a NASA wind
tunnel!

Ev'ry afternoon
When the clock strikes four

A crazy bunch of kids
Crash through that door, yeah

They throw off their coats
And leave the squares behind
And then they shake it,
Shake it, shake it
Like they're losing their mind
You'll never see them frown
'Cause they're
The nicest kids in town

Every afternoon
You turn your TV on

BACKUP

Oh-oo-oo-oo-oo-oo-oo-oo
Oh-oo-oo-oo-oo-oo-oo-oo
Oh-oo-oo-oo-oo-oo-oo-oo
Oh-oo-oo-oo-oo-oo-oo-oo
Hoot hoot hoot hoo-oot

Bop-be-ba, ba-ba-ba-ba,
bee-ba

Bop-be-ba, ba-ba-ba-ba,
bee-ba

Ow-oot
Hoot, ow-oot

Ow-oot, ow-oot

...Nicest kids in town

Na, na, na, na, na,
na-na-na-na

CORNY (continued)
And we know you
Turn the sound up
When your parents are gone

BACKUP (continued)
Na, na, na, na, na,
 na-na-na-na

And then you
Twist and shout — Ooh
For your favorite star — Ooh
And once you've
Practiced every step — Ooh
That's in your repertoire — Ooh
You better come on down — Ooh
And meet the
Nicest kids in town — ...Nicest kids in town

TRACY: Hurry, Penny, hurry—the show's already started! We're gonna miss it!

PENNY: I'm hurrying, Tracy, but my mother says I'm not allowed to perspire!

TRACY: C'mon!

PRUDY: Edna, is my laundry ready?

EDNA: (**EDNA** *is slaving away at her ironing board next to a huge stack of laundry.* **PRUDY** *is picking up her laundry.*) Who wants to know? Sure it is, hon. Come on up. That'll be three dollars.

PRUDY: (*digging in her purse*) That's pretty pricey for a few pairs of pettipants.

EDNA: I'm sorry, Prudy Pingleton, but there were some extra charges. Some of your personal stains required pounding on a rock.

 (**TRACY** *and* **PENNY** *enter.*)

TRACY: I'm home!

EDNA: Four o'clock. Guess I don't need to ask who got detention again. Tracy Turnblad, mind your manners and say hello to our guest.

TRACY: Hello, Mrs. Pingleton.

EDNA: And you, Penny?

PENNY: Hello, Mrs. Pingleton… I mean… Mother.

EDNA: (*to* PRUDY) Teenagers. They just love watching that Corny Collins.

PRUDY: Delinquents. It ain't right dancing to that colored music.

EDNA: Don't be silly, it ain't colored. The TV's black and white.

(PRUDY *exits with her bundle, shaking her head in disapproval.*)

CORNY	BACKUP
Nice white kids	Hoo-hoo
Who like to lead the way	Hoo-hoo
And once a month	Hoo-hoo
We have our Negro Day!	…Negro Day!
And I'm the man	Aah, ah
Who keeps it spinnin' 'round	Ah
Mr. Corny Collins	
With the latest, greatest	Huh! Huh! Wooo!
Baltimore sound!!	…Sou-ound
So every afternoon	
Drop everything	
	Bop-be-ba, ba-ba-ba-ba, be-ba
Who needs to read and write	
When you can dance and sing	
	Bop-be-ba, ba-ba-ba-ba, be-ba

CORNY (continued)
Forget about your algebra
And calculus
You can always do your homework
On the morning bus
Can't tell a verb from a noun
They're the nicest kids in town

BACKUP (continued)
Ow-oot
Hoot, ow-oot

Ow-oot, ow-oot

…Nicest kids in town
Oh-oo-oo-oo-oo-oo-oo-oo

CORNY & KIDS: Roll call!!

AMBER: I'm Amber!

BRAD: Brad!

TAMMY: Tammy!

FENDER: Fender!

BRENDA: Brenda!

SKETCH: Sketch!

SHELLEY: Shelley!

IQ: IQ!

LOU ANN: Lou Ann!

LINK: And I'm… Link!

TRACY: Oh, Link, kiss me again and again!

EDNA: Turn that racket down. I'm trying to iron in here.

CORNY
So, if every night you're shaking
As you lie in bed

Aah
Aah
Mony-mony, ooh,
 mony-mony

CORNY (continued)	BACKUP (continued)
And the bass and drums	Aah, aah, aah, aah
Are pounding in your head	
	Mony-mony, ooh,
	mony-mony
Who cares about sleep	How-oot!
When you can snooze in school	
	Hoot, ow-oot!
They'll never get to college	
But they sure look cool	
	Ow-oot, ow-oop!
Don't need a cap and a gown	
'Cause they're the	
Nicest kids in town	…Nicest kids in town
They're the	Oh-oo-oo-oo-oo-oo-oo-oo
Nicest, nicest	Oh-oo-oo-oo-oo-oo-oo-oo
They're the	Oh-oo-oo-oo-oo-oo-oo-oo
Nicest, nicest	Oh-oo-oo-oo-oo-oo-oo-oo
They're the	
Sugar and spice-est, nicest	…Kids in
Kids in town	Kids in town—hoot!

CORNY: And that was our new dance of the week—the "Stricken Chicken." We'll be right back.

(*Lights shift in the* TV *studio.*)

VELMA: And we're off! All right, people, how many times do I have to tell you? We do *not* touch ourselves—anywhere—while on camera. Tammy, lose the padding. You too, Fender.

(*The kids sheepishly turn away to remove their padding from bra and pants, respectively.*)

And Link, stop hogging the camera; you're not Elvis yet. Amber… Hog the camera.

AMBER: Yes, Mother.

VELMA: And *you*, Mr. Collins! None of that Detroit sound today. You have something against Connie Francis?

CORNY: The kids are just over the moon for rhythm and blues, Velma. They can't get enough.

VELMA: They're kids, Corny. That's why we have to steer them in the white direction... I mean... you know what I mean.

LINK: Amber, I've got something for you.

(*offers his ring*)

I figured, since we've been going together sort of... steadily... maybe we should make it official.

AMBER: Oh, Link. Your Council Member ring. How sweet. And it matches my hair color exactly!

(*They kiss.*)

VELMA: Ah, ah, ah! None of that! Save your personal lives for the camera! And we're back in five... four... three...

(*The lights change to indicate that they're back on the air.*)

CORNY: Now don't forget, guys and Gidgets—our very first prime-time spectacular is coming up on June 6th. We'll be live at Baltimore's brand-new Eventorium broadcasting nationwide!

Talent scouts will be on hand from all of the major record labels, and sponsoring the event will be none other than our own Ultra Clutch Hairspray. So, let's give a great big fawning Baltimore salute to the President of Ultra Clutch, Harriman F. Spritzer.

(**SPRITZER** *nervously steps out and waves to the room.*)

SPRITZER: Ultra Clutch is happy to bring you fine youngsters to national attention.

ALL: Our big break!

CORNY: Also, live on the special, we'll be crowning your choice for Miss Teenage Hairspray 1962!

AMBER: My big break!

EDNA: (*looking at the television*) Well, isn't she a lovely slim girl.

TRACY: (*to* **PENNY**) I guess Amber's pretty but she can't dance.

PENNY: Plastic little spastic.

TRACY: Oh no! I'm gonna kill myself. Look! She's wearing Link's council ring!

AMBER: (*reading from a cue card*) Hey, gang, don't forget to watch Mom and me next Thursday on Mother-Daughter Day. And I want to be your Miss Teenage Hairspray. Remember, a vote for me from you is a vote for me.

CORNY: What an unexpected ad lib, Amber. And speaking of expecting the unexpected, our own fun-loving, freewheeling Brenda will be taking a little leave of absence from the show. How long will you be gone, Brenda?

BRENDA: Nine months.

CORNY: So, it seems we'll have an opening for a girl who is just as fun loving, but maybe not quite as freewheeling. Wanna be one of the nicest kids in town? Cut school tomorrow and come on down to station wzzт to audition!

TRACY: Ohmigod! It's the dream of a lifetime. I have to go audition.

PENNY: Ohmigod! It's the dream of a lifetime. I have to go watch you audition.

EDNA: (*snapping off the tv*) That'll be enough of that for one day. No one is auditioning for anything. There'll be no cutting school in this house.

PENNY: But Mrs. Turnblad…

EDNA: Penny, go tell your mother she wants you.

PENNY: She does? I better hurry. Bye, Mrs. Turnblad. Bye, Tracy.

(**PENNY** *runs into* **WILBUR** *as he enters.*)

WILBUR: Whoa! Rush hour traffic! Hiya ladies. Since I got that new shipment of exploding bubble gum, business downstairs is booming! How are my two funny honeys?

EDNA: Oh, stop, Wilbur. You're the funny one.

TRACY: Daddy, tomorrow I'm auditioning to dance on a TV show.

EDNA: You're going to have to go further than that to get around me, young lady. No one's auditioning for anything. And what did I tell you about that hair? All ratted up like a teenaged Jezebel.

TRACY: Mother, you are so fifties. Even our first lady, Jackie B. Kennedy, rats her hair.

EDNA: Yeah? Well, you ain't no first lady, are ya? She's a hair-hopper—that's what got her put in detention again.

(*taking* **WILBUR** *aside*)

Wilbur, talk to her. Girls like Tracy… People like us… You know what I'm saying. They don't put people like us on TV—Except to be laughed at.

WILBUR: Tracy, this TV thing… You really want it?

TRACY: It's my dream, Daddy.

(*Pause*)

WILBUR: Then you go for it! This is America, babe. You gotta think big to be big.

EDNA: Being big is not the problem, Wilbur.

WILBUR: When I was your age my parents begged me to run away with the circus, but I said, "No. That's what you want. I have dreams of my own." I dreamt of opening a chain of joke shops worldwide. So, okay, I've still only got one, but some day, if I can figure out how to keep the air from leaking out of my sofa-sized Whoopee Cushion, I'm going to make a noise heard 'round the world!

> (**EDNA** *screams with delight!*)

You follow your dream, baby. I'm grabbin' an Orange Crush and heading back down to the Har-De-Har Hut. I've got my dream... And I wuv it!

EDNA: (*laughing again*) You're not helping, Wilbur!

> (**WILBUR** *exits and* **TRACY** *follows.*)

TRACY: Thanks, Daddy.

EDNA: Tracy, come back up here. I've got hampers of laundry and my diet pill is wearing off!

TRACY: But, Mama I want to be famous.

EDNA: You want to be famous? Learn how to get blood out of car upholstery. Now that's a skill you could take right to the bank. You think I wanted to spend my life washing and ironing other people's clothing? No, I wanted to design them. I thought I would be the biggest thing in brassieres. Well, you deal with what life gives you. Now start folding.

TRACY: Ugh.

> (*Focus shifts to* **PENNY** *and* **PRUDY**.)

PENNY: But Mom, all I was doing was watching Corny Collins over at Tracy's.

PRUDY: Didn't I forbid you from listening to race music? Oh, if the police ever locate your father he'll punish you good.

(*Focus shifts to* **AMBER** *and* **VELMA**.)

VELMA: Your dancing was atrocious today, Amber. I'm willing to lie, cheat, and steal to win you that Miss Hairspray crown, but you've got to work with me. Now let me at that zit!

EDNA: Stop! That's no way to treat clean clothes. One day you'll own "Edna's Occidental Laundry." Will you be ready?

TRACY: I hope not.

PRUDY: Don't contradict me!

VELMA: Don't disobey me!

EDNA: Don't even think about going to that audition.

GIRLS: Please!

MOMS: No!

GIRLS: Mother!!!!

O'Donnell, Meehan, Shaiman, and Wittman

SCENE TWO

"Mama, I'm a Big Girl Now"

MOMS
Stop!

PENNY
Stop telling me what to do

MOMS
Don't!

AMBER
Don't treat me like a child of two

MOMS
No!

TRACY
I know that you want what's best

MOMS
Please?

TRACY
But Mother, please

ALL
Give it a rest!!!

MOMS
Stop! Don't! No!

GIRLS
Please!

MOMS
Stop! Don't! No!

GIRLS
Please!

MOMS
Stop! Don't! No!

GIRLS
Please!
Mama, I'm a big girl now!

(Scene shifts to the GIRLS' *bedroom vanities.)*

TRACY	BACKUP
Once upon a time	Ooh's…
When I was just a kid	
You never let me do	
Just what the older kids did	
But lose that laundry list	
Of what you won't allow	
'Cause Mama,	…Mama
I'm a big girl now	I'm a big girl now

AMBER	
Once upon a time	Ooh's…
I used to play with toys	
But now I'd rather play around	
With teenage boys	
So, if I get a hickey,	
Please don't have a cow	
'Cause Mama,	…Mama
I'm a big girl now	I'm a big girl now

PENNY	
Ma, I gotta tell you	Ooh, ooh, ooh
That without a doubt	Ooh's…
I get my best	
Dancing lessons from you	
You're the one who taught me	Ooh, ooh, ooh
How to "Twist and Shout"	Ooh's…
Because you shout non-stop	

O'Donnell, Meehan, Shaiman, and Wittman

PENNY (continued)
And you're so twisted too-oo
Wa-oh-oh-oh-oh

TRACY	**BACKUP** (continued)
Once I used to fidget	Ooh's...
'Cause I just sat home	
AMBER	
But now I'm just like Gidget	Ooh's...
And I gotta get to Rome!	
PENNY	
So say, arrivederci!	
	Ooh's...
TRACY	
Toodle-loo!	Ooh's...
AMBER	
And Ciao!	Ooh's...
ALL GIRLS	
'Cause Mama,	...Mama
I'm a big girl now	I'm a big girl now
	Ooh, ooh, ooh
ALL	
Stop! Don't! No! Please!	
Stop! Don't! No! Please!	
Stop! Don't! No! Please!	
Mama, I'm a big girl now	
	Hey Mama, say Mama
TRACY	
Once upon a time	Ooh's...
I was a shy young thing	
Could barely walk and talk	
So much as dance and sing	
But let me hit that stage	
I wanna take my bow	

TRACY (continued)
'Cause Mama,
I'm a big girl now

BACKUP (continued)
…Mama
I'm a big girl now

AMBER
Wa-oh-oh-oh-oh
Once upon a time
I used to dress up "Ken"
But now that I'm a woman
I like bigger men
And I don't need a Barbie Doll
To show me how
'Cause Mama,
I'm a big girl now

Ooh's…

…Mama
I'm a big girl now

ALL GIRLS
Ma, you always taught me
What was right from wrong
And now I just wanna give it a try
Mama, I've been in the nest
For far too long
So please give a push
And Mama, watch me fly

Oh, oh, oh, wa
Ooh…
…Give it a try
Wa, ooh's…

And Mama, watch me fly

AMBER
Watch me fly

Hey Mama, say Mama

PENNY
One day I will meet a man
You won't condemn

Ooh's…

AMBER
And we will have some kids
And you can torture them

Ooh's…

TRACY
But let me be a star
Before I take that bow

Ooh's…

O'Donnell, Meehan, Shaiman, and Wittman

ALL GIRLS
'Cause Mama,
I'm a big girl now

BACKUP (continued)
Mama
I'm a big girl now

PENNY
Oh-oh-oh

ALL GIRLS
Mama,
I'm a big girl now

Mama
I'm a big girl now

AMBER
Hey-hey-hey

ALL GIRLS
Mama,
I'm a big girl now

Mama
I'm a big girl now

AMBER
Ooh, such a big, big girl!

Ooh!

ALL GIRLS
I'm a big girl now...

ALL
Stop! Don't! No! Please!
Stop! Don't! No! Please!
Stop! Don't! No! Please!
Mama, I'm a big girl now!!!

(*End of Scene Two*)

SCENE THREE
THE AUDITION

(*The TV station. The* **COUNCIL MEMBERS** *and* **VELMA** *sit behind a long table.*)

LOU ANN: That's it, Mrs. Von Tussle. She was the last candidate.

VELMA: Really? That's all? Who would've guessed that Baltimore girls were all such skags? My, how this town has gone downhill since I was crowned Miss Baltimore Crabs.

(**TRACY** *and* **PENNY** *enter, out of breath. The* **COUNCIL** *starts to break up.*)

TRACY: Phew! I thought we'd never get here. Stupid bus crash!

PENNY: All my life I imagined what this place would look like. This isn't it.

TRACY: (*to* **VELMA**) Hi there. Am I too late to audition?

VELMA: (*dismissing her*) Not too late, dear. Just too much.

PENNY: Tracy. Look, it's Link!

TRACY: Link Larkin. So near, and yet so gorgeous.

LINK: I know, those girls were all over me. I don't know how Rock Hudson stands it.

(*And he walks right into* **TRACY**.)

Excuse me, little darlin', I hope I didn't dent your 'do.

(**ALL** *freeze except* **TRACY** *and* **PENNY**.)

"I Can Hear the Bells"

TRACY
I can hear the bells

PENNY: Tracy, are you all right?

TRACY
Don't 'cha hear 'em chime

PENNY: I don't hear anything.

TRACY
Can't 'cha hear my heartbeat
Keeping perfect time
And all because he

Touched me
He looked at me and stared, yes he
Bumped me
My heart was unprepared when he
Tapped me
And knocked me off my feet
One little touch
Now my life's complete 'cause when he

Nudged me
Love put me in a fix, yes it
Hit me
Just like a ton of bricks, yes my
Heart burst
Now I know what life's about
One little touch
And love knocked me out and,

	BACKUP
I can hear the bells	I can hear the bells
My head is spinning	
I can hear the bells	I can hear the bells
Something's beginning	
Everybody says	
That a girl who looks like me	
Can't win his love	
Well, just wait and see	
'Cause I can hear the bells	I can hear the bells

O'Donnell, Meehan, Shaiman, and Wittman

TRACY (continued)	BACKUP (continued)
Just hear them chiming	
I can hear the bells	I can hear the bells
My temprature's climbing	
I can't contain my joy	
'Cause I fin'ly found the boy	
I've been missin'	
Listen, I can hear the bells	
	Ah's...
Round one	Round one
He'll ask me on a date and then	
Round two	Round two
I'll primp but won't be late because	
Round three's	Round three
When we kiss inside his car	
Won't go all the way	
But I'll go pretty far then	
Round four	Round four
He'll ask me for my hand and then	
Round five	Round five
We'll book the wedding band so by	
Round six	Round six
Amber, much to your surprise	
This heavyweight champion	
Takes the prize and	Takes the prize and
I can hear the bells	I can hear the bells
My ears are ringing	
I can hear the bells	I can hear the bells
The bride's maids are singing	
	COUNCILETTES
Everybody says	Ah's...
That a guy who's such a gem	
Won't look my way	
But the laugh's on them 'cause	

TRACY (continued) **BACKUP**

I can hear the bells I can hear the bells
My father will smile
I can hear the bells I can hear the bells
As he walks me down the aisle
My mother starts to cry
But I can't see 'cause Link and I
Are French kissin'
Listen, I can hear the bells

 Ah... ah... ah... ah...
I can hear the bells I can hear the bells
My head is reeling
I can hear the bells I can hear the bells
I can't stop the pealing

Everybody warns Ah...
That he won't like what he'll see Ah...
But I know that he'll look Ah... ah
Inside of me, yeah Inside of me, yeah

I can hear the bells I can hear the bells
Today's just the start 'cause
I can hear the bells I can hear the bells
And till death do us part

And even when we die Oo... oo...
We'll look down from up above Oo... oo...
Remembering the night Oo... oo...
That we two fell in love ...Two fell in love
We both will share a tear
And he'll whisper as we're reminisin' ...Nisin'
Listen!
I can hear the bells She can hear the bells

I can hear the bells She can hear the bells

I can hear the bells Bong
 Bong
 Bong
 Bong

(The song ends. The **COUNCILETTES**, *led by* **AMBER**, *interrogate* **TRACY**.)

AMBER: And what are *you* doing here?

TRACY: I came to audition for Corny. My name is Tracy Turnblad. And, like you, I go to Patterson Park High…

LOU ANN: I've seen you.

AMBER: Who could miss her? Aren't you usually in detention about now?

TRACY: I cut school to come down here. Isn't that too cool? I'm a little nervous, can I start over. I assure you I'll calm down, right after I have a heart attack!!

(music in)

Well, I brought my own 45s, so if you put 'em on, I'll show you my stuff!

LOU ANN: Haven't you already shown us enough?

(The **COUNCILETTES** *snicker.)*

"(The Legend of) Miss Baltimore Crabs"

VELMA
Oh my God
How times have changes
This girl's either blind
Or completely deranged
Ah, but time seemed to halt
When I was "Miss Baltimore Crabs"

TRACY: It's been my childhood dream to dance on this show!

AMBER: Well, maybe you oughta go back to sleep!

VELMA
Childhood dreams
For me were cracked
When that damn Shirley Temple
Stole my frickin' act
But the crown's in the vault
From when I won "Miss Baltimore Crabs"
Those poor runner-ups
Might still hold some grudges

They padded their cups
But I screwed the judges
Those broads thought they'd win
If a plate they would spin in their dance
Ha! Not a chance!

'Cause I hit the stage
Batons ablaze
While singing "Aida"
And preparing cheese souffles!
But that triple somersault
Was how I clinched "Miss Baltimore Crabs"

 (*to the* **COUNCILETTES**)

Fire away, girls!

TAMMY
You're too wide from the back

AMBER
Honey, look at her front!

VELMA
Wait, are we on "Candid Camera"?
Ok, where is Allen Funt?

AMBER
Do you dance like you dress?

LINK
Girls, there's no need to be cruel!

VELMA: Would you swim in an integrated pool?

(*The music stops dead and the* **COUNCIL** *gasps in shock.*)

TRACY: I sure would. I'm all for integration. It's the New Frontier!

VELMA: Not in Baltimore it isn't.

TRACY: Um, where's Corny? I'd love to dance for him.

VELMA: I'm the producer and may I be frank?

(*music back in, ominously building, building*)

VELMA	**COUNCIL MEMBERS**
First impressions can be tough	Ooh's
And when I saw you, I knew it	
If your size weren't enough	
That last answer just blew it!	

And so, my dear, so short and stout
You'll never be "in"

VELMA & COUNCIL MEMBERS
So we're kicking you out!

VELMA
With your form and your face
Well, it isn't your fault
You're just caught in a case of "Miss...

VELMA & COUNCIL MEMBERS
Baltimore...

VELMA
...Crabs!"
You're free to go.

TRACY: Uh, thank you?

PENNY: I could tell they secretly liked you.

> (**LITTLE INEZ** *runs on.*)

LITTLE INEZ: Hello Ma'am, may I please audition?

VELMA: Of course not!
But you can bow and exalt
'Cause I am "Miss Baltimore...

VELMA & COUNCIL MEMBERS
...Crabs"

> (*The scene shifts as* **TRACY** *and* **LITTLE INEZ** *step down-stage and pass one other.*)

TRACY & LITTLE INEZ
I know every step
I know every song
I know there's a place where I belong...

TRACY: (*she reaches the mirror*) Why do they have to be so mean? "You're short, you're stout, you're not Council material." I wear the latest fashions, I keep up with all the styles. I'm teasing my hair as high as I can!

> (*She sprays her hair with hairspray.*)

Will they give me a chance? Encouragement? Appreciation? No, all I ever hear is...

SCENE FOUR
DETENTION

(**PRINCIPAL** and **TRACY** are isolated in a spotlight.)

PRINCIPAL: Tracy Turnblad, once again your monumental hair-don't has seriously obstructed everyone's view of the blackboard. As Principal of Patterson Park High, I condemn you to three more days of detention!

(*Lights up on* **TRACY** *in detention. Around her are* **SEAWEED, LORRAINE, GILBERT, THAD, DUANE,** *and* **STOOIE,** *asleep at his desk.* **LORRAINE** *is at the blackboard writing repeatedly, "I will not talk in speech class."*)

TRACY: Detention! Is there no pity for a teen just trying to fit in?

SEAWEED: Maybe you oughtn't try so hard?

TRACY: Excuse me. You get detention just about every time I do, and I've never seen you complain.

SEAWEED: Oh, but I do. This is my way of complaining.

(**SEAWEED** *turns on a small transistor radio. Music starts and he does a soulful little dance.*)

It's how I use my blues.

DUANE: Use them blues, brother. You gotta use 'em to lose 'em.

TRACY: Hey, that move's swift.

SEAWEED: The man can dine me on a diet of detention so long as he don't starve me of my tunes.

(*another step*)

Here's a little something-something signified to say, "Hello, my name's Seaweed J. Stubbs. What's yours?"

TRACY: That's unbelievable. Can I do that?

SEAWEED: I don't know. Can you?

(**TRACY** *and* **SEAWEED** *dance together.*)

TRACY: Hello. My name is Tracy Turnblad.

GILBERT: Not bad for a white girl.

SEAWEED: Ain't no black and white in here. Detention is a rainbow experience.

(**SEAWEED** *does another step.*)

TRACY: What's that step?

SEAWEED: Oh this? I call this one "Peyton Place after Midnight." I use it to attract the opposite sex.

(**TRACY** *jumps in with him.*)

Fearless, girl. You really got it going on.

TRACY: Yes! This program's joining you already in progress.

(**TRACY** *suddenly freezes with recognition.*)

Oh my God! I just realized who you are. I've seen you dance on Negro Day.

LORRAINE: Of course you have. His mom hosts the show.

TRACY: Your mom is Motormouth Maybelle, the DJ? That makes you like royalty! Negro Day is the best. I wish every day was Negro Day.

SEAWEED: At our house it is.

TRACY: Wait! Corny Collins is hosting the sophomore hop tomorrow night. If he saw me dancing like this with you, maybe he'd put me on his show.

GILBERT: If you two dance together in public, the only show *you'll* get on is the eleven o'clock news.

Seaweed: So, how you feeling about detention now?

Tracy: I'm a bad, bad girl who needs to be punished!

> (*They all begin to dance. The* PRINCIPAL *walks in on them.*)

Principal: Smiling, laughing, dancing in detention? Tracy Turnblad, you can give up all hopes of college. I'm putting you in Special Ed with the rest of these characters!

Tracy: Special Ed? What do you do in Special Ed?

Stooie: We do musicals!

All: Wah-hoo!

> (*The school bell rings.*)

> (*End of Scene Four*)

SCENE FIVE
THE MADISON

(*Patterson Park High School gymnasium.* **CORNY** *takes the microphone.*)

CORNY: Hey, there, sophomores and sophomores at heart! I'm honored to be your guest DJ here at PPHS. So with no further ado-do, let's do-do some dancing. It's the hottest dance around and it was born right here in Baltimore. What's it called, kids?

STUDENTS: The Madison!

CORNY: And where'd you see it first?

STUDENTS: *The Corny Collins Show*!

CORNY: Let's form two big, strong lines — it's Madison time! Go!

(*The* **KIDS** *form lines and dance.*)

STUDENTS
Baby don't sleep.
Baby don't eat.
Baby just likes to do the boink-boink.

(**TRACY** *enters with* **SEAWEED**.)

STUDENTS (*under dialogue*)	**TRACY**
Baby don't call.	Hurry, Seaweed, the dance has
Baby won't meet.	already started!
Baby just likes to do the boink-boink.	
	SEAWEED
I try to lie down	All right, but remember, you
But she's always on her feet	gotta dance with your crowd
To do the boink-boink.	and I gotta dance with mine.

TRACY: Oh look, it's the Madison, my favorite!

SEAWEED: You keep your eye on Corny. This could be your big chance.

TRACY: Then you better keep an eye on me.

CORNY: Now when I say "Hit it," show me a big, bad Baltimore Box... Hit it!

> (*The* KIDS *do the dance.*)

> (**TRACY** *insinuates herself in...*)

STUDENTS
Boink, boink.

LITTLE INEZ: How come we always have to dance in the back?

SEAWEED: I don't know. There's them and there's us. That's just the way it is.

CORNY: When I say "Hit it," take it to the basket like Wilt the Stilt... Hit it! (*to* AMBER) Amber, who's your friend? She's like a breath of fresh mountain air.

AMBER: You got the mountain part right. Oink-oink.

CORNY: Now when I say "Hit it," let's take a drive down Druid Hill... Hit it! Hang a right... feed the monkey... he's in the back seat.

> (**ALL** *dance.*)

STUDENTS
Boink, boink.

LINK: (*to* TRACY) Hey, little darlin'. Haven't we met somewhere?

TRACY: Link Larkin actually spoke to me. I'll never wash this ear again.

CORNY: When I say "Hit it," let's make like Jackie Gleason—hommina, hommina, hommina... Hit it!

> (**ALL** *start step.*)

ALL: And away we go!

TRACY: Hi, Corny!

CORNY: Hey, cupcake. What's your name?

TRACY: (*as she does the "My Name Is" step*) I'm Tracy Turnblad.

CORNY: What else have you got hiding in those Buster Browns?

TRACY: Well, here's one I picked up in detention. It's called "Peyton Place after Midnight." I use it to attract the opposite sex.

SEAWEED: Hey, hey, hey! Check her out everybody!

(**TRACY** *does the step as the* **KIDS** *join in.*)

LINK: That girl's as free as the wind.

AMBER: Everybody stop liking her!!!!

CORNY: Okay everybody, let's take it home. Crazy!

(*The* **KIDS** *do the Madison.*)

And that, Baltimorians, is how we do the Madison.

SCENE SIX
SUCCESS

STUDENTS
Oh-oo-oo-oo-oo-oo-oo-oo
Oh-oo-oo-oo-oo-oo-oo-oo
Oh-oo-oo-oo-oo-oo-oo-oo
Hoot hoot hoot hoo-oot

CORNY: Hey, there teenage Baltimore. You're just in time for *The Corny Collins Show*!

SPRITZER: Brought to you by Ultra Clutch!

CORNY: And it tastes good too.

Today's jam-packed edition will feature Link Larkin singing a special request Top 40 hit "It Takes Two." So, let the party begin!

(*Focus shifts to the* **TURNBLAD** *home.*)

PENNY: Hurry, Miz Turnblad! Hurry, Mr. Turnblad! Come see what's on TV.

WILBUR: (*entering hurriedly*) Penny Pingleton, this better be important.

PENNY: It is!

EDNA: Oh no. Don't tell me Khrushchev has his shoes off again!

"Nicest Kids in Town" (reprise)

ALL: Roll Call!!

AMBER: I'm Amber!

BRAD: Brad!

TAMMY: Tammy!

FENDER: Fender!

BRENDA: Brenda!

SKETCH: Sketch!

SHELLEY: Shelley!

IQ: IQ!

LOU ANN: Lou Ann!

LINK: Link!

TRACY: And I'm… Tracy!

(**WILBUR, EDNA,** *and* **PENNY** *shriek.*)

CORNY & KIDS
So, if every night you're shaking
As you lie in bed

And the bass and drums
Are pounding in your head

WILBUR, EDNA, & PENNY
Go, Tracy! Go, go, Tracy!

CORNY
Who cares about sleep
When you can snooze in school

They'll never get to college
But they sure look cool

Don't need a cap and a gown
'Cause they're the
Nicest kids in town

They're the
Nicest, nicest

BACKUP
How-oot!

Hoot, ow-oot!

Ow-oot, ow-oop!!

Nicest kids in town

Oh-oo-oo-oo-oo-oo-oo
Oh-oo-oo-oo-oo-oo-oo

CORNY (continued)	**BACKUP** (continued)
They're the	Oh-oo-oo-oo-oo-oo-oo
Nicest, nicest	Oh-oo-oo-oo-oo-oo-oo
They're the	
Sugar and spice-est, nicest	Kids in…
Kids in town	Kids in town—hoot!

CORNY: Yeah! And that was our dance of the week—"Peyton Place after Midnight," introduced to you by our brand new Council member, Miss Tracy Turnblad.

EDNA: Oh, my word! Tracy! Live in our own living room!

WILBUR: I think I've seen her here before.

PENNY: And she's going to be a regular.

EDNA: Imagine, my little girl, regular at last.

PENNY: Hi, Tracy. It's me, Penny!

EDNA: She can't hear you.

> (*The phone rings and she answers it.*)

Hello?… Yes, this is her childhood home. No, I'm not her father.

> (*Back to the show…*)

CORNY: So let's wave a wistful bye-bye to Brenda—see you next year.

COUNCIL MEMBERS: (*waving to* **BRENDA** *as she exits*) Awww…

CORNY: …and inaugurate the newest member of our Council, Tracy Turnblad! Cozy up to old Corny and tell us about yourself, Trrrrace.

TRACY: Well, I go to Patterson Park High, I watch your show, and I do absolutely nothing else.

(**ALL** *applaud and cheer.*)

But someday I hope to be the first woman president of the world or a Rockette. You got to think big to be big!

CORNY: And if you were president, what would your first official act be?

TRACY: Well, I'd make every day Negro Day!

VELMA & SPRITZER: Aaaaiiiieeeee!!!!!

(**SPRITZER** *runs off in horror, and* **VELMA** *follows.*)

CORNY: I read you like tomorrow's headlines, Trace! What do you say, kids? Looks like we might just have a hot new candidate for Miss Teenage Hairspray.

AMBER: (*grabbing the microphone*) No, she can't be Miss Hairspray! She's the before in the Metrecal diet ad, and I'm the after, and afters always win!

CORNY: Amber, what a comedian! So, Tracy, tell us true, how would you like Link Larkin to sing a song just for you?

AMBER: (*grabbing the microphone*) No! He *can't* because everyone knows that whenever he sings, he's singing to me. He's completely involved with me, see?

CORNY: Right. So, Tracy, tell us true, how would you like Link Larkin to sing a song just for you?

TRACY: Would I? Would I?

AMBER: (*grabbing the microphone*) You people are ignoring the laws of nature!

CORNY: Link Larkin, our own budding Elvis, will now sing to the equally blooming Tracy Turnblad his version of this week's Top 40 hit, "It Takes Two."

AMBER: Mother!

"It Takes Two"

BACKUP
Ooh oo oo oo oo ooh
Ooh oo oo oo
It ta-akes two
Ooh oo oo oo oo oo
Ooh doo doo wop!

LINK
They say it's a man's world
Well, that cannot be denied
But what good's a man's world
Without a woman by his side
And so I will wait
Until that moment you decide

That I'm your man ...I'm your man
And you're my girl And you're my girl
That I'm the sea ...I'm the sea
And you're the pearl And you're the pearl
It takes two baby, It takes two-oo-oo
It takes two It takes two-oo
 Doo doo wop

A king ain't a king Ooh
Without the pow'r behind Ooh
 the throne
A prince is a pauper, babe Ooh
Without a chick to call his own Ooh
So please, darling, choose me Aah-aah
I don't wanna rule alone Aah-aah

Tell me I'm your king ...I'm your king
And you're my queen And you're my queen
That no one else That no one else
Can come between Can come between

LINK (continued)
It takes two, baby
It takes two

Lancelot had Guinevere
Mrs. Claus has old St. Nick
Romeo had Juliet
And Liz, she has her Dick
They say it takes two to tango
But that tango's child's play
So take me to the dance floor

And we'll twist the night away

Just like Frankie Avalon
Has his favorite Mouseketeer
I dream of a lover babe
To say the things I long to hear
So come closer, baby
Oh and whisper in my ear

TRACY
Yeah...

LINK
That you're my girl
And I'm your boy

That you're my pride

And I'm your joy
That I'm the sand
And you're the tide
I'll be the groom
If you'll be my bride
It takes two, baby
It takes two
It takes two, baby

BACKUP (continued)
It takes two-oo-oo
It takes two-oo
Oo-don'cha know

Hoot, hoot, hoot, hoot
Ow-oot, hoot, hoot, hoo-oo
Hoot, hoot, hoot, hoot
Ow-oot, hoot, hoot, hoo-oo
Hoot, hoot, hoot, hoot
Ow-oot, aah aah aah ooh
Aah aah aah aah

Aah aah aah aah

Ooh
Ooh wa-ooh wa
Ooh-oo-oo-oo-ooh
...Wop wa
Ooh-ooo
Ooo-aah

TRACY & GUYS
...I'm your girl
...You're my boy

...You're my pride

...I'm your joy
...I'm the sand
...You're the tide
...Be the groom
...Be my bride
It takes two-oo-oo-oo
It takes two-oo-oo-oo
Aah-aah

LINK & TRACY	**GUYS**
It takes two	...Two-oo-oo-oo-oo
	Oo-oo-oo-ooh

(*As the song is ending...* **TRACY** *kisses* **LINK**. *Lights shift to "off air."* **VELMA** *enters with* **SPRITZER** *nipping at her heels.*)

SPRITZER: Negro Day everyday? That chubby Communist girl and kissing on the mouth with possibly parted lips... I assure you, controversy is not what Ultra Clutch wishes to promote.

CORNY: Negroes and chubby girls buy hairspray, too, Mr. Spritzer.

SPRITZER: Mrs. Von Tussle, how do you plan to handle this?

VELMA: I plan to start by firing him!

CORNY: You can't fire Corny Collins from *The Corny Collins Show*.

VELMA: Why not? They do it all the time on *Lassie*!

CORNY: Mr. Spritzer, to keep your audience, you got to keep up with the times.

VELMA: This show's fine the way it is.

CORNY: Bringing Tracy on is just the beginning. I've got terrific ideas for updating the show.

SPRITZER: I'm getting one of my sick headaches. Is there a place where I might lie down?

VELMA: There's a bed in my office.

(**SPRITZER** *goes off*. **VELMA** *turns on* **CORNY**.)

So you've got ideas, do you? And going behind my back to put this no-talent Commie on the show is one of them?

CORNY: Damn right, Velma. It's time we put kids on the show who look like the kids who watch the show.

VELMA: Not while I'm producing it.

CORNY: I was thinking it might be time to change that, too.

VELMA: Are you threatening me, Collins?

CORNY: Aw, you know me, Velma! On the other hand, I could always take the show to Channel 11.

(**CORNY** *exits laughing.*)

"Velma's Revenge"

VELMA
Oh my God
That snake that sings
He's a puppet
But I hold the purse and the strings
God, I knew Negro Day
Would bring chaos and change
Now he's pushing this pinko
Who might give us all mange

She's a blemish, a blackhead
That must be expelled
There's a standard of beauty
That must be upheld
You can say I'm a bigot
But it just isn't true
Look, I love Sammy Davis
And he's black and a Jew!

But they better get set
For a full-out assault

VELMA (continued)
They should never have boiled
Miss Baltimore Crabs

 (End of song. End of Scene Six.)

SCENE SEVEN
WELCOME TO THE SIXTIES

(*The* TURNBLAD *home.* EDNA *is frazzled from hours on the phone.*)

EDNA: (*into the phone*) Yes. Thank you so much!… I'm sure Tracy appreciates your vote for Miss Teenage Hairspray. Yes! And she loves you too. Very much. Whoever you are. Goodbye!

(*The phone rings again.*)

This is crazy.

(*answering*)

Hello? What am I wearing? A housecoat, scuffies, and Supp-Hose. What are *you* wearing? Hello? Hello?

(*Puzzled, she hangs up.*)

TRACY: (*bursting in excitedly*) Mama, did you see, did you see me?

EDNA: Of course I did. It was on television. I had to. The phone's been ringing like we was a telethon. To think, the fruit of my womb, a beloved TV icon.

TRACY: So you're not mad?

EDNA: Mad? How could I be mad? You're famous! If you'd only told me you was going to get on the show, I never would have said you couldn't. But sit… tell me, is fame all you thought it would be? Are you happy, honey?

TRACY: Yes, Mama. And I think I'm in love.

EDNA: I know. I've been following. But you and I are going to have to have a talk about crooners. You can learn a lot from the mistakes of Miss Debbie Reynolds.

(*The telephone rings.*)

There it goes again.

TRACY: (*answering the phone*) Hello? Yes, this is Tracy Turnblad. Hello, Mr. Pinky.

EDNA: (*in an excited whisper*) Mr. Pinky? *The* Mr. Pinky? As in "Mr. Pinky's Hefty Hideaway — Quality Clothes for Quantity Gals"? That Mr. Pinky?

TRACY: You want to hire me as your exclusive spokesgirl and fashion effigy?

> *(to* **EDNA***)*

What's an effigy?

> (*back on the phone*)

That's very flattering, but I'm afraid all business must go through my agent....It would be our pleasure. We'll be right over, Mr. Pinky. Goodbye!

(**TRACY** *hangs up the phone.*)

EDNA: An agent! I don't know any agents. How about a nice bail bondsman?

TRACY: Mother, put that thing down. I'm taking my new agent to the Hefty Hideaway and then out on the town.

EDNA: Who? Me? Tracy Turnblad, fame has gone to your head and left you wacky. You need a top-shelf professional. Who handled the Gabor sisters? Well, who didn't?

TRACY: Mama, there's a great big world out there I know nothing about. When things get rough, a girl needs her mother.

EDNA: Hon, I'll be right beside you, if that's what you want. And together we'll claw your way to the top. But can't we do it over the phone? I haven't been out of this apartment since Mamie Eisenhower rolled her hose and bobbed her bangs.

"Welcome to the '60s"

TRACY
Hey Mama, hey Mama, look around
Everybody's groovin' to a brand-new sound
Hey Mama, hey Mama, follow me
I know something's in you that you wanna set free

> (*A glamorous black female trio magically step out of a poster that promotes their upcoming concert.*)

So let go, go, go of the past now
Say hello to the love in your heart
Yes, I know that the world's been spinning fast now
You gotta get yourself a brand-new start

DYNAMITES

Hey Mama	**BACKUP**
Welcome to the sixties	Welcome to the sixties!
Oh-o-o-o-o	
Oh Mama	
Welcome to the sixties	Welcome to the sixties!
Oh-o-o-o-o	
Oh Mama	
Go, go, go!	Go, go, go!
	Welcome to the sixties!
	Wo oo oo oo oo oh
	Hey-a Mama
	Yeah, yeah, yeah
	Yeah, yeah, yeah

> (**TRACY** *and* **EDNA** *hit the streets of Baltimore for a fashion and hair make-over.*)

TRACY
Hey Mama, hey Mama
Take my hand

EDNA
First let's make a pit stop at
The wiener stand

TRACY
Hey Mama, hey Mama
Take a chance

EDNA
Tracy, it's been years
Since someone asked me to dance

TRACY & DYNAMITES
So let go, go, go

TRACY
Of the past now

TRACY & DYNAMITES
Say hello

TRACY
To the light in your eyes

Yes, I know that the world's
 spinning fast now
Ya gotta run the race to win
 the prize

DYNAMITES
Hoo hoo hoo
Ooh ooh ooh

ALL
Hey Mama, welcome to the sixties
Oh oh oh oh oh oh oh oh
Oh Mama, welcome to the sixties
Oh oh oh oh oh oh oh
Go Mama, go, go, go!

Welcome to the sixties
Oh oh oh oh oh
Hey Mama

O'Donnell, Meehan, Shaiman, and Wittman

Yeah, yeah, yeah
Yeah, yeah, yeah

> (*They arrive at The Hefty Hideaway to find* **MR. PINKY** *giving away free doughnuts.*)

MR. PINKY: Free jelly doughnuts while they last. Eat 'em up, girls. I've got ten tons of taffeta inside.

TRACY: Hello, Mr. Pinky. I'm Tracy.

MR. PINKY: There's my shining star! Television doesn't do you justice.

EDNA: Oh, Mr. Pinky, you certainly picked a lovely girl to put the plus in your plus-sizes.

MR. PINKY: Now, Tracy, this can't be your agent. She must be your gorgeous big sister.

EDNA: (*squealing with delight*) Why, Mr. Pinky, you're twisting my head! I'm not her gorgeous big sister, I'm…

MR. PINKY: …54 Double D?

EDNA: Triple E!!!

MR. PINKY: Oh, mama, I've hit the motherlode! Step inside and let's make a deal.

> (**MR. PINKY** *and* **EDNA** *disappear into the store.*)

ALL
Your mama's welcoming the sixties
Oh oh oh oh oh oh oh oh
Your mama's welcoming the sixties
Oh oh oh oh oh oh oh
Go Mama, go, go, go!

> (**FANS** *besiege* **TRACY** *for photos and autographs.*)

DYNAMITES
Welcome to the rhythm of a brand-new day

TRACY
Take your old-fashioned fears

DYNAMITES
And just throw them away

MR. PINKY'S STAFF
You should add some color and a fresh new 'do

DYNAMITES & ENSEMBLE
'Cause it's time for a star
Who looks just like you!

DYNAMITE 1
Don'cha let nobody try to steal your fun
'Cause a little touch of lipstick never hurt no one

DYNAMITE 2
The future's got a million roads for you to choose
But you'll walk a little taller in some high-heel shoes

DYNAMITE 3
And once you find the style that makes you feel like you
Something fresh and new

DYNAMITES
Step on out
Hear us shout

TRACY & DYNAMITES
Mama, that's your cue!!!
Yeah, yeah, yeah

> (**EDNA** *emerges from the shop looking resplendent.*)

EDNA
Hey Tracy, hey Tracy
Look at me!
I'm the cutest chickie
That ya ever did see

Hey Tracy, hey baby
Look at us
Where is there a team
That's half as fabulous?!

 (**TRACY** *enters Hefty Hideaway.*)

ALL
I let go, go, go

EDNA
Of the past now

ALL	**BACKUP**
Said hello	Ooh's

EDNA
To this red carpet ride

ALL
Yes, I know

EDNA
That the world's spinning fast now
Tell Lollobrigida to step aside!

Your Mama's	Welcoming the sixties
Welcoming the sixties	
Oh-o-o-o-o	Wo, oh, oh, oh
Oh Mama's	Welcoming the sixties
Welcoming the sixties	
	Oh, oh, oh, oh

EDNA (continued)
Oh-o-o-o-o

BACKUP (continued)
Wo, oh, oh, oh
Welcome to the sixties

ALL
Open the door for the girl
Who has more, she's a star
Tracy, go, go, go!

(**TRACY** *re-enters in a matching outfit.*)

TRACY & EDNA
Hey Mama
Welcome to the sixties
Oh-o-o-o-o
Oh Mama
Welcome to the sixties
Oh-o-o-o-o

Go Mama
Go, go, go!

Welcome to the sixties

Welcome to the sixties

Wo, oh, oh, oh
Welcome to the sixties
Oh, oh, oh, oh

Wo, oh, oh, oh
Go, go, go!

Welcome to the sixties
Go Mama
Oh, oh, oh, oh

Wo, oh, oh, oh
Go Mama
Go Mama
Go, go, go!
Go, go, go!

(Song ends. End of Scene Eight.)

SCENE EIGHT
DODGEBALL

(Patterson Park High School playground. **LINK, FENDER,** *and their male pals warm up on the far side of stage.* **AMBER, LOU ANN,** *and* **TAMMY** *enter.* **SHELLEY** *enters wearing a wig designed to make her look like* **TRACY.** **AMBER** *stares.)*

AMBER: What is that supposed to be?

SHELLEY: Isn't it the dreamiest? It's called "The Tracy." Everyone who's anyone has one.

GYM TEACHER: Gather up, students. Brace yourselves for scatter dodge ball.

AMBER: Kathy Schmlnk told me she heard Tracy was in the back seat of a car with two boys at once… playing tonsil hockey… in the nude!

TAMMY: Is it true they put her in Special Ed?

AMBER: Yup. Tracy Turnblah is a tramp *and* she's retarded. That's right—she's fast and slow at the same time!

 (crosses to **LINK***)*

Link Larkin, how could you kiss that beehived buffalo right on the… air?

LINK: That didn't mean anything, Amber. It was just a cool way to end the song.

 *(**TRACY, SEAWEED,** and the **SPECIAL ED KIDS** enter.)*

FENDER: Hey, here they come! Special *Ed*! Snicker, snicker, sneer, sneer.

LINK: That ain't cool, Fender.

GYM TEACHER: Ha, ha! Special Ed! Ha, ha!

TRACY: (*sees* **LINK**. *Prays to herself*) Oh, Link, if fate forces you to throw the ball at me today, seal it with a kiss.

SEAWEED: Got a prayer for me too? This game can get pretty vicious.

TRACY: What is scatter dodge ball anyway?

SEAWEED: It's sort of like a protest rally. Looks like a good idea until the police show up, then you better scatter and dodge.

PENNY: (*coming to* **TRACY**) Hi, Tracy. Sorry about your Special Ed-ness. But think of it as a testament to the record-breaking extremes your hair has reached. I'm so jealous.

(*noticing* **SEAWEED**)

Hello.

TRACY: Seaweed, this is my best friend, Penny Lou Pingleton.

SEAWEED: Wait, I've seen you before. At the gum machine getting your Wrigley's.

PENNY: (*proudly*) I do two packs a day.

SEAWEED: Hmm… All that chewing must make the muscles in your mouth mighty strong.

PENNY: (*blushing with pride*) Not really. Probably just average.

AMBER: Well, well, well, Tracy Tugboat, you finally found a title you could win: Miss Special Ed!

LINK: Knock it off, Amber.

TRACY: Amber Von Tussle, you have acne of the soul.

GYM TEACHER: Students… Commence!

(*And with a shrill whistle the game begins. **AMBER** gets the ball and throws it at **TRACY**.*)

AMBER: Hey, thunder thighs, dodge this!

TRACY: You throw like a girl!

SEAWEED: Hey, no fair throwing at the head.

GYM TEACHER: That's right, go for his nuts!

(*The ball barely misses his head.*)

LINK: Everybody take it easy. This isn't World War Three.

(***AMBER** gets the ball away from **LINK** and takes dead aim at **TRACY'S** head.*)

AMBER: Says you! Eat dodge ball, Trampy Ton-o-lard!

(*She viciously snaps the ball right into **TRACY'S** head. **TRACY** crumples to the ground, knocked out. A whistle blows.*)

GYM TEACHER: Game over.

(*school bell rings*)

Class dismissed! All right girls, who wants to take a shower? Extra credit!

(*The **GIRLS** and **GYM TEACHER** exit.*)

AMBER: Poor Tracy. So tragic, I forgot to cry. Are you coming, Link?

LINK: Amber, that wasn't necessary.

AMBER: I said, are you coming, Link?

LINK: In a minute.

AMBER: I'll be waiting under the bleachers.

(**AMBER** *exits.* **SEAWEED**, **PENNY**, *and* **LINK** *go to* **TRACY'S** *aid.*)

PENNY: Uh oh, Tracy? Are you dead?

SEAWEED: I better go get the school nurse.

PENNY: I'll go with you.

(*They go off together leaving* **LINK** *alone with* **TRACY**.)

LINK: (*at* **TRACY'S** *side*) Tracy? Tracy, how you doin'? Gee, you're beautiful when you're unconscious.

(*A bell tone identifies "I Can Hear the Bells" as* **LINK** *mouths those words.*)

TRACY: (*reviving*) Where am I? Link?

LINK: You better? For a second there it looked like "Teen Angel" time.

TRACY: (*into* **LINK'S** *eyes*) Wherever I am, please, no one change the channel.

LINK: You've got a funny way of putting things. I like that.

PENNY: (*returning with* **SEAWEED**) The nurse is out sick, but look what Seaweed found.

SEAWEED: (*removing the stuff from his pocket*) Band-Aids and Q-Tips! Oh, and a rubber. No, I guess that's mine.

PENNY: He's so nurturing.

TRACY: Oh, Link, this is my friend Seaweed.

(*The* **BOYS** *grunt toward each other.*)

LINK: How you doin'?

SEAWEED: How *you* doin'?

O'Donnell, Meehan, Shaiman, and Wittman

PENNY: (*to* TRACY) How are you doing?

TRACY: How do you think? I just got creamed in front of the entire school.

SEAWEED: Hey, Trace, I know what'll make you feel better. My mom's pitchin' a platter party at our record shop on North Avenue. Wanna come check it out?

PENNY: I, too, feel not good. May I also come check it out?

SEAWEED: You surely may.

TRACY: I've never been to North Avenue before.

LINK: Would it be safe up there for, you know, us?

SEAWEED: Don't worry, cracker boy, It's cool.

TRACY: What do you think, Link?

LINK: I think getting to know you is the beginning of a whole lot of adventure.

PENNY: Imagine being invited places by colored people.

TRACY: It feels so hip!

SEAWEED: Glad you feel that way, friends. 'Cause not everybody does.

"Run and Tell That!"

SEAWEED
I can't see
Why people look at me
And only see
The color of my face

SEAWEED (continued)
And then there's those
That try to help, God knows
But always have to
Put me in my place

Now I won't ask you
To be color blind
'Cause if you pick the fruit
Then girl, you're sure to find

The blacker the berry
The sweeter the juice
I could say it ain't so
But darlin', what's the use

The darker the chocolate
The richer the taste
And that's where it's at…
…Now run and tell that!!

Run and tell that!

I can't see
Why people disagree
Each time I tell them
What I know is true

And if you come
And see the world I'm from
I bet your heart
Is gonna feel it too

Yeah, I could lie
But baby, let's be bold
Vanilla can be nice
But if the truth be told

BACKUP
Run and tell that!

Run and tell that!

I can't see
Ooh's

And if you come
Ooh's

Vanilla can be nice
Uh-huh

O'Donnell, Meehan, Shaiman, and Wittman

SEAWEED (continued)
The blacker the berry
The sweeter the juice
I could say it ain't so
But darlin', what's the use

The darker the chocolate
The richer the taste
And that's where it's at...

...Now run and tell that!

Run and tell that!

Run and tell that!

Run and tell that!

BACKUP (continued)
Oo
Uh-huh

Oo-oo

Oo

And that's where it's at—
 woo!

Run and tell that!

Run and tell that!

Run and tell that!

Run and tell that!

(The song continues as we segue directly into...)

SCENE NINE
THE RECORD SHOP

(**MOTORMOUTH MAYBELLE'S** *record shop.* **LITTLE INEZ**
and other **BLACK TEENS** *are dancing as* **SEAWEED, PENNY,**
TRACY, *and* **LINK** *arrive. Music continues under the*
dialogue.)

LITTLE INEZ: Hey, you're Tracy. You're my favorite dancer on *The*
Corny Collins Show.

SEAWEED: This is my sister, Little Inez.

TRACY: Sure. I saw you at the auditions.

LITTLE INEZ: Well, you're the only one who did, 'cause they kicked
me out on my young, gifted, and black behind.

LITTLE INEZ	**BACKUP**
I'm tired of coverin' up	(hand claps)
All my pride	
So give me five	So give me five
On the black-hand side	On the black-hand side
I've got a new way of movin'	
And I got my own voice	
So how can I help	So how can I help
But to shout and rejoice	But to shout and rejoice
People 'round here	Ooh...
Can barely pay their rent	
They're try'n to make dollar	Ooh...
outta fifteen cent	
But we got a spirit	Ooh...
Money just can't buy	
It's deep as a river	It's deep as a river
And soars to the sky!!	And soars to the sky!!

SEAWEED	**BACKUP** (continued)
I can't see	I can't see
The reason it can't be	
The kinda world	
Where we all get our chance	(ad libs)
The time is now	The time is now
And we can show 'em how	
Just turn the music up	
And let's all dance	
'Cause all things are equal	Ooh's
When it comes to love	
Well, that's not quite true	
'Cause when push comes to shove…	Huh
The blacker the berry	Oo
The sweeter the juice	Uh-huh
I could say it ain't so	
But darlin', what's the use	Oo-oo
The darker the chocolate	Oo
The richer the taste	
And that's where it's at…	And that's where it's at—
	woo
Now run and tell that!!	
	Run and tell that!
Run and tell that!	
	Run and tell that!
You better run and tell that!	
	Run and tell that!
Run and tell that!	

(*The song ends and* **MOTORMOUTH** *makes her entrance.*)

MOTORMOUTH: There's platters of tunes and food on the table. What else would you expect from…

ALL: Ms. Motormouth Maybelle!

SEAWEED: Mama, I brought some friends.

O'Donnell, Meehan, Shaiman, and Wittman

MOTORMOUTH: Whoop-dee-doo, what a coup! The ever sparkin', Sir Link Larkin!

LINK: Always nice to see you, Ms. Motormouth.

PENNY: I'm Penny Lou Pingleton and I'm very pleased and scared to be here.

MOTORMOUTH: You're welcome, kitten, to come and sit in.

TRACY: This is just so Afro-tastic. Can I say how thrilled I am to meet you, Miz Motormouth. I'm Seaweed's friend, Tracy.

MOTORMOUTH: Oh, yes, indeedy. I've seen you, sweetie. All aglow on Corny's Show.

TRACY: Gee, thanks. But I'm only there because of your son. Why can't we all dance together like this on TV?

MOTORMOUTH: Think we haven't tried? We've pleaded, begged, and lied. We pressured the mayor, petitioned the gov, and what did we get?

MOTORMOUTH & KIDS: One day a month.

SEAWEED: Enough talk. We came to dance. Let's play some hide and seek!

(*Music starts.*)

TRACY, PENNY, & LINK: The dirty boogie!

(*They start to dance when the door suddenly bursts open.*)

AMBER: Aaaaaaiiiiiieeeeeee!!!! Link! What are you doing in this huge crowd of minorities?

LINK: Trying to fit in. What are you doing?

AMBER: I waited for you under the bleachers until half-way through the JV track meet, then I saw you getting on the North Avenue bus and I followed you here in my new car.

LINK: We're having a blast. Come, jump in.

(*The door bursts open again.*)

VELMA: Aaaaaaaaiiiiiiieeeeeee!!!!! Amber! Has anyone touched you?

MOTORMOUTH: Y'all better hustle. Here's Von Tussle.

VELMA: I saw you getting into your darling, new car, so I followed you in mine. Motormouth, are you brainwashing these children?

MOTORMOUTH: They're only dancing.

TRACY: Yeah, we're dancing.

VELMA: (*taking in* TRACY) Oh! I should have known you'd be at the bottom of this barrel.

(*The door opens again and this time* EDNA *enters with a take-out bag.*)

EDNA: Ooooooooohhhhhh!!!!!! Tracy, that was you I saw!

(*calling out the door*)

Wilbur! It was the kids I saw.

TRACY: Mama, what are you doing here?

EDNA: I had a sudden craving for chicken and waffles, so we drove up to Ruby's Take-Out across the way. Hello everyone. I'm Tracy's mom.

VELMA: (*taking in* EDNA) Oh! So, you're what spawned that!

EDNA: Excuse me?

VELMA: I guess you two are living proof that the watermelon doesn't fall very far from the vine.

EDNA: Tracy, be a dear, hold Mommy's waffles.

(**EDNA** *takes a threatening step toward* **VELMA** *as* **WILBUR** *enters.*)

WILBUR: All right! A party! Anyone for chicken and waffles?

CINDY: If we get any more white people in here, it'll be a suburb.

VELMA: (*starting toward the door*) Come on, Amber. Let's get back to the right side of the tracks, if our cars are still there.

AMBER: (*following* **VELMA**) Let's go, Link.

LINK: Amber, you're being rude to these people.

VELMA: (*as if to a dog*) Amber. Come!

AMBER: (*just like Mama*) Link. Come!

(*He doesn't move.*)

Link! Come!!!

LINK: Amber. Go.

AMBER: (*trying to save face*) What ever happened to the bland, spineless boy I fell in love with? Mother, come.

(*She marches out the door.*)

VELMA: With pleasure.

(*They are gone. A pause and then...*)

EDNA: I didn't care for them.

LITTLE INEZ: Are all white people like that?

WILBUR: Naw... Just most.

TRACY: Well, I know how we can start changing that. If kids saw us dancing together on TV, they'd realize that we're not so different after all. We just want to have a good time.

SEAWEED: You saying you and Link would be willing to dance with us on Negro Day? That *would* be earth shaking!

LINK: (*getting nervous*) Tracy...

TRACY: No. We're not going to dance on Negro Day.

LINK: (*relieved*) Whew.

TRACY: (*pointing to* **MOTORMOUTH**) You're going to crash White Day!

MOTORMOUTH: White Day is everyday. Ya gotta get more specific than that!

TRACY: Is tomorrow specific enough? Think: It's Mother-Daughter Day. Ms. Motormouth, you work for the station. They could never turn you and Little Inez away. And once the two of you break the barrier, we'll all be free to dance on TV.

SEAWEED: That thinking's downright revolutionary.

LITTLE INEZ: We'll set off sparks, like Rosa Parks!

MOTORMOUTH: Child, it ain't that easy. This ain't Parcheesi. What if they call the cops? People could get hurt.

TRACY: Then we'll all walk out together. There's me. There's Link and I'm sure we can get the others. Without dancers, they've got no show.

MOTORMOUTH: (*to* **WILBUR** *and* **EDNA**) What a decision; your girl's got vision.

EDNA: We've always tried to teach her to do what's right.

WILBUR: …and give correct change.

LINK: (*pulling* **TRACY** *aside*) Tracy, you can't do this. You're new to the Council. You'll be blackballed and thrown off the show for sure.

TRACY: That's why we're all doing it together.

LINK: Not me.

TRACY: You don't think segregation is wrong?

LINK: I like these people. But whether or not they're on TV won't get me a recording contract.

> (*realizes this sounds too shallow*)

That came out wrong. I've been singing and dancing and smiling on that show for three years waiting for it to lead to my break. You've got everything: brains, talent, personality. Me? I've got one chance to get seen nationwide. Saturday night is everything I've worked for. I'm not gonna throw it away. C'mon, I'm leaving and you gotta too.

> (*He starts toward the door*)

TRACY: No! I want to do this, and so should you. It's what's right. Stay, Link. Please stay.

LINK: Sorry.

TRACY: But you and me together… I was just starting to think…

LINK: Sure. Me too. But I don't know. It's getting too complicated. And there's still Amber.

See ya, little darlin'.

> (*He exits*)

PENNY: I'm sorry, Tracy.

TRACY: Oh Mama... how could I think Link Larkin would ever care about someone like me?

EDNA: Why wouldn't he? You're a beautiful girl. It's just Eddie Fisher all over again.

TRACY: Mama, don't tease. I really like him. I've never felt anything like this before.

EDNA: I know. And he probably likes you too. It's just... boys are not the brightest things. Give him time. I'm sure he'll figure out he's crazy about you.

TRACY: You have to say that. You're my mother.

EDNA: I'm more than your mother. I'm a woman in love and we know about this stuff.

WILBUR: But Tracy, he could be right. Should you risk your career?

TRACY: I never would have gotten on the show without Seaweed. No, it's payback time.

WILBUR: That's my girl.

TRACY: (*determined*) Okay. So this is how we're gonna do it; tomorrow, everyone bring your mothers...

PENNY: ...and sisters!

TRACY: ...and meet around the corner from the studio and make signs!

PENNY: Yes! And put words on them!

TRACY: Ms. Motormouth, you and Little Inez will walk in first. Me and Mama will be right behind you.

EDNA: Excuse me?

TRACY: They'll never be able to shove them back out the door with us blocking it!

EDNA: I'm sorry, Tracy. But no one said anything about me appearing on television. I'm sorry but I simply can not appear on television at my present weight.

MOTORMOUTH: You can't let weight restrict your fate! Look at me! I'm on TV!

EDNA: Oh, but, Ms. Motormouth, you're a celebrity. While I'm a simple housewife of indeterminate girth.

MOTORMOUTH: The bigger the girth, the more you're worth! Mr. Turnblad, you don't mind that the missus here is an Ample American, do you?

WILBUR: Not at all. I think of her as prime real estate.

MOTORMOUTH: Yeah! Nice and roomy. You listen to me!

"Big, Blonde, and Beautiful"

MOTORMOUTH
Once upon a time
Girl, I was just like you
Never let my extra large
Largesse shine through

Hair was brown and nappy
Never had no fun
I hid under a bushel
Which is eas'ier said than done!

Then one day my grandma
Who was big and stout

MOTORMOUTH (continued)
She said you gotta love yourself
From inside out

And just as soon as I learned
How to strut my funky stuff
I found out that
The world at large
Can't get enough so…

Bring on that pecan pie
Pour some sugar on it,
Sugar, don't be shy

Scoop me up a mess
Of that chocolate swirl
Don't be stingy,
I'm a growing girl

I offer big love
With no apology
How can I deny the world
The most of me

I am not afraid
To throw my weight around
Pound by pound by pound

Because I'm
Big, blonde, and beautiful
There is nothin' 'bout me
That's unsuitable

No one wants a meal
That only offers the least
When, girl, we're serving up
The whole damn feast

BACKUP
Ooh oo oo, ooh oo oo!

O'Donnell, Meehan, Shaiman, and Wittman

MOTORMOUTH (continued)
Slice off a piece
Of that hog head cheese
Then take a look inside
My book of recipes **BACKUP** (continued)
Now, don't you sniff around Hoo-hoo-ooh-ooo
For something fluffy and light ...Fluffy and light
I need a man
Who brings a man-size appetite

I'll use a pinch of sugar ...Pinch of sugar
And a dash of spice And a dash of spice
I'll let ya lick the spoon
Because it tastes so nice

I'll keep it in my oven Hoo-hoo-ooh-ooo
Till it's good and hot ...Good and hot
Keep on stirring
Till it hits the spot

Because I'm
Big, blonde, and beautiful Big, blonde, and beautiful
And Edna, girl
You're lookin' so recruitable
Why sit in the bleachers Hoo-oo-oo-oo-oo
Timid and afraid
When, Edna,
You can be your own parade!

TRACY: So, how about it, Mama?

EDNA: Well, I *am* big, I *am* blonde...ish, and if you say I'm
 beautiful, I guess I'm beautiful. Okay, I'll do it!

 (**ALL** *cheer. The scene shifts and protest signs are
 distributed. Among them: "Let my people dance," "Onward
 twistin' soldiers," and "Mothers for brotherhood."*)

ALL
Look out
Old Baltimore
We're marching in
And we ain't shufflin'
Through that old back door

EDNA
And Tracy, I will join your fight
If I can keep up this pace

WILBUR
And girls, I'll be right at your side
If I can find some space

MOTORMOUTH
So you can
Hold your head up
Just as big as ya please
You know they'll hear me knockin'
With the two of these!

MOTORMOUTH, WILBUR, & TRACY
Tomorrow, side by side
We'll show the world what's right

EDNA
Looks like I'm touching up my roots tonight!

MOTORMOUTH
And we'll be
Big, blonde, and beautiful

So face the fact
It's simply irrefutable

BACKUP (continued)
Ooh oo oo, ooh oo oo!

Ooh-ooh-ooh

Hoot!
Hold your head up
Just as big as ya please

Ow!!

Big, blonde, and beautiful

Hoo-hoo
Hoo-hoo

O'Donnell, Meehan, Shaiman, and Wittman

MOTORMOUTH (continued)
Can't ya hear that rumbling?
That's our hunger to be free
It's time to fin'ly taste equality

BACKUP (continued)
Hoo-oo-oo-oo-oo
...Hunger to be free
...Fin'ly taste equality

(*The* CORNY COLLINS MOTHERS *and* DAUGHTERS *appear.
The* PROTESTERS *march into the studio causing mayhem.*)

COUNCIL MEMBERS
On Mother-Daughter Day
Where thin is in, we're white as wool

MOTORMOUTH
Well ladies, big is back!
And as for black
It's beautiful

PROTESTERS
...Beautiful

MOTORMOUTH
All shapes and sizes,
follow me

EDNA
Let's bust their chops

VELMA
Quick, call the cops!

MOTORMOUTH
We're gonna
Dance our way to victory!

Dance our way to victory!

COUNCIL MOTHERS & DAUGHTERS: Stay away! This isn't
Negro Day!

DYNAMITES
And get us on tv!

PROTESTERS: 2... 4... 6... 8...
TV's got to integrate!

PROTESTERS: 2... 4... 6... 8...
 TV's got to integrate!

**COUNCIL MOTHERS &
DAUGHTERS:** Stay away!
 This isn't Negro Day!

DYNAMITES
And get us on TV!

(*Police sirens wail. A paddy wagon backs in. Its doors open and two* OFFICERS *emerge. As the* PROTESTERS *continue their march, they are loaded into the paddy wagon.*)

MOTORMOUTH: We're here to dance!

EDNA: We're here to stay!

LINK: Tracy, this was beautiful!

MOTORMOUTH
Big, blonde, and beautiful lead the way!

ALL
No one's getting on TV today

(*The curtain falls on Act One.*)

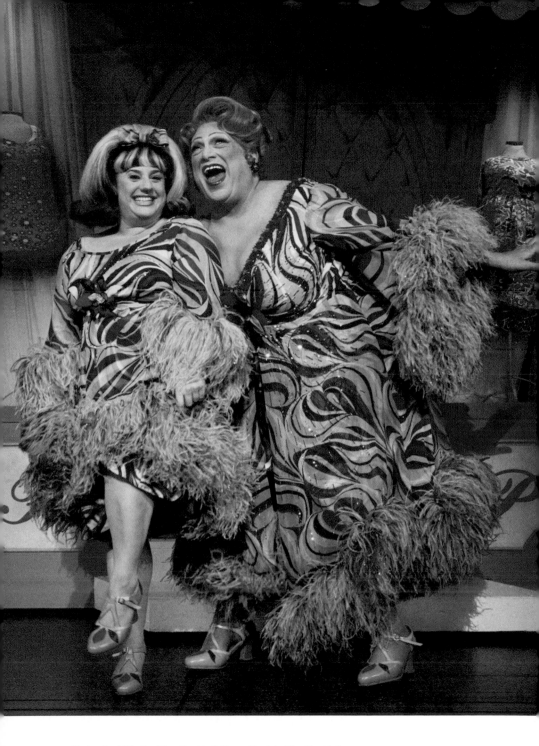

Marissa Jaret Winokur (Tracy Turnblad), Harvey Fierstein (Edna Turnblad).

All production photos by Paul Kolnik.

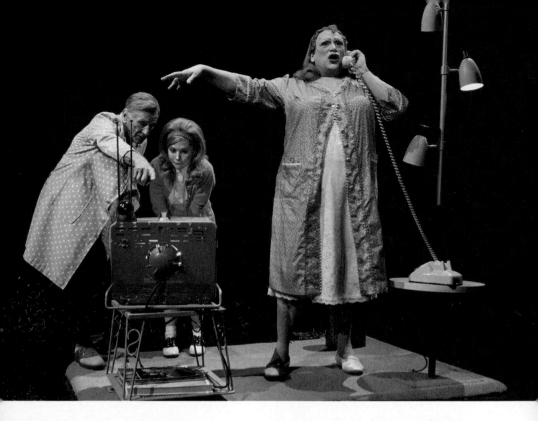

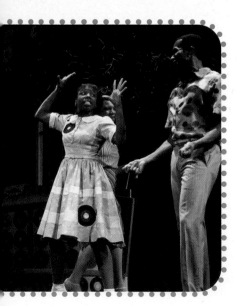

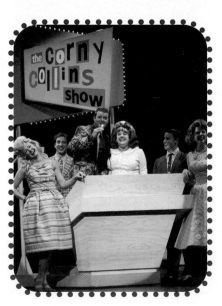

Top: Dick Latessa (Wilbur Turnblad), Kerry Butler (Penny Pingleton), Harvey Fierstein (Edna Turnblad). **Bottom left:** Danelle Eugenia Wilson (Little Inez) and members of the cast. **Bottom right:** Laura Bell Bundy (Amber Von Tussle), Clarke Thorell (Corny Collins), Marissa Jaret Winokur (Tracy Turnblad), with members of the cast.

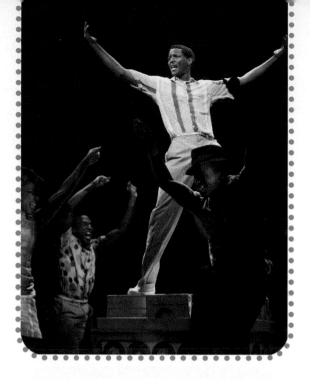

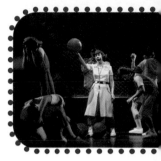

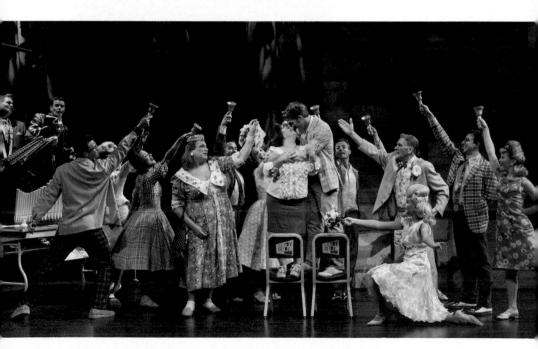

TOP LEFT: Corey Reynolds (Seaweed J. Stubbs) and members of the cast. **TOP RIGHT:** Corey Reynolds (Seaweed J. Stubbs) and Kerry Butler (Penny Pingleton). **MIDDLE RIGHT:** Jackie Hoffman with members of the cast. **BOTTOM:** Cast of *Hairspray*.

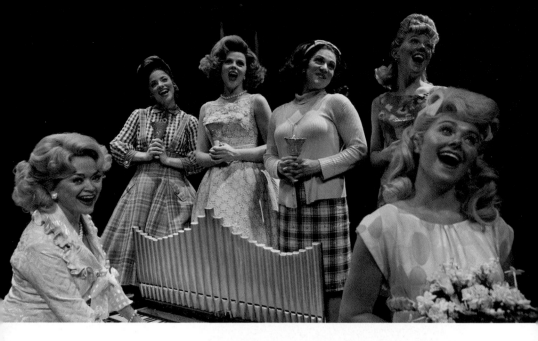

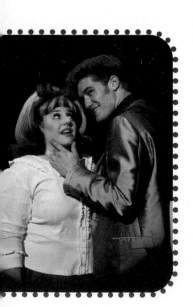

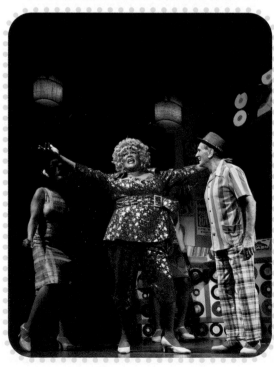

Top: Linda Hart (Velma Von Tussle), cast members, and Laura Bell Bundy (Amber Von Tussle). **Bottom left:** Marissa Jaret Winokur (Tracy Turnblad) and Matthew Morrison (Link Larkin). **Bottom right:** Mary Bond Davis (Motormouth Maybelle) and Dick Latessa (Wilbur Turnblad).

ACT TWO

SCENE ONE
WOMEN'S HOUSE OF DETENTION

*(The **FEMALE CAST**, with the exception of **PRUDY**, are in jail! A **MATRON** stands watch over them.)*

"Big Dollhouse"

WOMEN
I gotta get out,
I gotta get out,
I gotta get out,
How'd I get in this slammer
This cooler,
This big dollhouse!

MATRON: Ok, ladies, welcome to the big dollhouse! For those of youse new to the penal system, I'm letting you know now that I don't stand for boozing, doping, cussing, gambling, fighting, or any other sort of unladylike behavior. Think of me as a mother… who eats her young.

VELMA
Locked up with all these lowlife women

EDNA
And horizontal stripes
Ain't exactly slimmin'

AMBER
Is there anybody here who can dry clean my blouse?

MATRON
It's the maid's day off

ALL
In the big dollhouse

LITTLE INEZ
Lady Justice where have you gone?

EDNA
Ooh, Wilbur, check, I think I left the iron on!

VELMA
Did you see Corny laughing?
I could murder that louse!

ALL
Honey, that'll getcha life
In the big dollhouse
Big house!

VELMA
Locked up here in the pen

ALL
Big house!

AMBER
No phone!

EDNA
No food!

MOTORMOUTH
No men!

EDNA
I need a conjugal visit
From my loving spouse

MATRON
Honey, just drop the soap

ALL
In the big dollhouse

MATRON: Exercise, ladies! Get in the trenches you wenches.

EDNA
Yoo-hoo, my stomach's a little sour
I haven't had food
In over an hour

MATRON
You just had a pizza, my kugel, a mouse!

ALL
There's no food left in the big dollhouse

VELMA
Uh, Matron
I have got to complain

HOOKER #2
Mira Mami, don't I know you
From 1st and Main?

VELMA
Eek, call my shysters,
Lipshitz and Strauss
I gotta get sprung
From the big dollhouse

ALL
Big house!

LITTLE INEZ
No fair!

EDNA
No food!

PENNY
No fun!

ALL
Big house!

MOTORMOUTH
And our fight has just begun
'Cause it's freedom's flame
That *she'd* like to douse
So we must break out of this

ALL
Big dollhouse

MATRON: You do the crime, you gotta do the time.

TRACY
Penny, I can't take all this waiting
I've lost my man
Plus, my hair's deflating!

PENNY
Well Tracy,
I hate to grumble or grouse

ALL (*screaming*)
But it's *your* fault that we're in
This big dollhouse!!

BEATNIK CHICK
Hey, cool it, ladies
No need to shout
And don't cha got an old man
To bail you out?

VELMA
Ha! Her daddy's a loser,
a pervert, a souse!

EDNA
Well, it's just us girls
In the big dollhouse

ALL
Big house!

AMBER
God, I'm too young to fry!

ALL
Big house!

EDNA
I'm busting out!

MOTORMOUTH
Girl, so am I!

ALL
Lady Justice, hear my plea
'Cause the big dollhouse
The big dollhouse
The big dollhouse
Ain't big enough for me
For me
For me

EDNA
For me!

(*The song ends.*)

MATRON: Recess is over! Time to pay your debt to society. Please keep in mind, tipping is permitted.

(*She exits.*)

EDNA: To think I'd live to have a rap sheet. If my mother were alive…

(*arm around* **TRACY**)

…she'd be so proud. Remember, your grandma was a suffragette.

TRACY: Right. You haven't seen the last of us, Mrs. Von Tussle. We'll be marching again, and soon, to the beat of a whole new era!

VELMA: Bang your drum, Bonzo. No one cares. Don't get any more cute ideas about protesting or even showing up at the special. I'll have armed guards surrounding the Eventorium to make sure Tracy doesn't get within 100 miles of that place. Game, set, match.

(*A* **GUARD** *enters with a clipboard.*)

GUARD: Von Tussle, Velma? Von Tussle, Amber?

AMBER: That's us.

GUARD: Ladies, you're free to go with the sincere apologies of the state of Maryland and the personal compliments of the governor himself.

VELMA: The governor? Really? Sweet, chubby Millard. We dated on and off in college. Now if you Doublewide Twins will excuse me, I have a national TV spectacular to produce.

AMBER: (*turning back to* **TRACY**) I was never here. This never happened. Oh, Tracy. Any message for Link? Place it on my lips, and I'll be sure he gets it.

VELMA: So long, Balti-morons!

(*They exit laughing.*)

EDNA: I still don't care for them.

MOTORMOUTH: I hear ya, Miz T. This old jail just got a whole lot nicer.

(*The* GUARD *reenters and unlocks the cell door.*)

GUARD: You've got a visitor. Bail has been posted.

MOTORMOUTH: Thank the Lord for those who can afford.

WILBUR: (*entering gleefully*) I posted bail.

EDNA: Wilbur! How?

WILBUR: Simple really. I mortgaged the Har-De-Har Hut.

TRACY: Oh, Daddy.

EDNA: But that place is your life.

WILBUR: You two are my life. Bail for everyone! Bail for the house! You're free to go.

(*All the* WOMEN *file out of the cell. The* TURNBLADS *hang back.*)

MOTORMOUTH: The Turnblad gang are real good folks. They have the heart. They get the jokes.

MATRON: All prisoners kindly turn in your tap shoes on the way out.

WILBUR: Shall we make haste?

GUARD: Hold it, sucker man. We're keeping that rotund rabble rouser on ice.

WILBUR: I paid for everyone. Got a group discount.

GUARD: (*reading from an official-looking document*) Tracy Turnblad is herewith and forthwith withheld, without bail. She is to be moved to solitary confinement and held there until further notice by special order of the governor's office. So, there.

(*He slams the cell door with* **TRACY** *inside.*)

TRACY: The governor's office?! Mrs. Von Tussle! Manipulating our judicial system just to win a contest is un-American.

GUARD: Don't make things worse for yourselves. Move out peacefully.

WILBUR: I'm not going anywhere without my daughter.

TRACY: It's okay, Daddy. They can't keep me here forever. Besides, I've got a lot to think about. I might as well do it in solitary refinement.

GUARD: I'm counting to three and then I'm rearresting you all for illegal trespass.

WILBUR: Let's go. We can't do Tracy any good here.

(**EDNA** *pauses at the* **GUARD**...)

EDNA: Touch one hair on my daughter's head, and I'll be back to teach you a whole new meaning for split ends.

(*They all file out the door.*)

LITTLE INEZ: Keep the faith, baby.

MOTORMOUTH: They haven't heard the last from us.

PENNY: You're so lucky to get out of the algebra final.

(*All are gone except* **TRACY**.)

"Good Morning Baltimore" (reprise)

TRACY
Oh, oh, oh
I'm all alone
My heart has grown but it's broken, too.

This morning life was a
Baltimore fairy tale
Now I can't make bail!

My mother's in shock
My father's in hock
I much prefer Link's arms
To jailhouse cells

So Link, please
Rescue me now
'Cause I love you
And this prison smells.
Link, hear the bells!

And get ready Baltimore
There's a bright, brand-new day in store
Let me out so this dream's unfurled
I'll eat some breakfast,
Then change the world!

And I promise Baltimore
Once I cha-cha right out of that door
The world's gonna wake up and see
Link's in love with me!

(*End of song. End of Scene One.*)

SCENE TWO
HAR-DE-HAR HUT

(**WILBUR** *and* **EDNA** *are at home later that day.* **WILBUR** *is busily working on a jumbo hairspray can model.* **EDNA** *is on the phone.*)

EDNA: Hello? Yes, Mr. Pinky. Yes, of course I understand you have an empire to protect. Yes. I'll return the outfits. The pettipants, too. I scarcely wore them twice… but Mr. Pinky, she's just a little girl and little girls make mistakes. If they didn't—where would other little girls come from?… Yes, I understand… it is too bad… Goodbye.

(*She hangs up and bursts into hysterics.*)

Oh, Wilbur, I think I'm going mental!

WILBUR: I'm closing up.

(*A "Rube Goldberg" type trick pulls the "closed" sign on the shop.*)

EDNA: Oh, Wilbur, my stomach's in knots. I bought a double box of Malomars, and they're still in the box.

WILBUR: Calm down, sweetheart.

EDNA: I can't calm down. There are names for women who abandon their daughters who've gotten themselves arrested for trying to integrate an after-school, sock hop type television show. Yes, there are names, and Hallmark does not make a card for any of them!

WILBUR: You can't worry about people calling you names. You know how many times I've been called "crazy"? But I say, "Yeah, crazy. Crazy like a loon." Anyway, we haven't abandoned Tracy. In fact, I got just what she needs here; stand back.

(*He pushes the aerosol can top — it explodes.*)

What d'ya think? Isn't it a doozy?

EDNA: Impressive. But how's it gonna help our Tracy?

WILBUR: You'll be surprised.

EDNA: Oh, sure! You're a visionary inventor saving the day. Tracy's a teen idol reshaping the world. And what am I? I had a dream too, you know. I used to make all my own clothes, remember? Until I wandered beyond the boundaries of the largest McCall's pattern. But I always dreamed that one day I would own my own line of queen-sized dress patterns.

WILBUR: You were good, Edna.

EDNA: Yeah? And where's it gotten me? Twenty years later I'm still washing and mending and ironing everyone else's clothing.

WILBUR: One day, Edna.

EDNA: No day, Wilbur. My time's come and gone. I'm a worn out pair of bobby sox, and the elastic's all stretched. Oh, Wilbur, I suddenly feel so old.

WILBUR: (*music*) Nonsense, doll. You're as spry as a slinky. Whenever I'm near you it's like grabbing hold of a giant joy buzzer.

"(You're) Timeless to Me"

WILBUR
Styles keep a-changin'
The world's rearrangin'
But Edna, you're timeless to me
Hemlines are shorter
A beer costs a quarter
But time cannot take what comes free

You're like a stinky old cheese, babe
Just gettin' riper with age

WILBUR (continued)
You're like a fatal disease, babe
But there's no cure
So let this fever rage

Some folks can't stand it
Say time is a bandit
But I take the opposite view
'Cause when I need a lift
Time brings a gift
Another day with you
A twist or a waltz
It's all the same schmaltz
With just a change in the scenery
You'll never be old hat
That's that!
Ooh, ooh, you're timeless to me

EDNA
Fad's keep a-fadin'
And Castro's invading
But Wilbur, you're timeless to me

Hairdo's are higher
Mine feels like barbed wire
But you say I'm chic as can be!

You're like a rare vintage ripple
A vintage they'll never forget
So pour me a teeny weenie triple
And we can toast the fact we ain't dead yet!

I can't stop eating
Your hairline's receding
And soon there'll be nothing at all
So, you'll wear a wig
While I roast a pig
Hey! Pass that Geritol

EDNA (continued)
Glenn Miller had class
That Chubby Checker's a gas
But they all pass eventually

You'll never be passé
Hip hooray!
You're timeless to me

 (*dance break*)

EDNA
You're like a broken down Chevy
All you need is a fresh coat of paint

WILBUR
And Edna, you've got me goin' hot and heavy
You're fat and old, but baby, boring you ain't!

WILBUR & EDNA
Some folks don't get it
But we never fret it
'Cause we know that time is our friend

And, it's plain to see
That you're stuck with me
Until the bitter end

And we got a kid
Who's blowin' the lid
Off the Turnblad family tree

EDNA
You'll always hit the spot
Big shot!
You're timeless to me

WILBUR
You'll always be du jour
Mon amour
You're timeless to me

EDNA
You'll always be first string

WILBUR
Ring-a-ding-ding!

WILBUR & EDNA
You're timeless to me

EDNA
You're timeless to me

WILBUR
You're timeless to me

WILBUR & EDNA
You're timeless to me!!

"(You're) Timeless to Me" (reprise)

WILBUR & EDNA
You need a fresh coat of plaster

EDNA
But Wilbur, I'm still hot to trot

WILBUR
Yeah Edna, you're like the Hindenburg Disaster

EDNA
I'm full of gas!

WILBUR
But you won't be forgot!!

WILBUR & EDNA
Love take a lickin'
But we keep on tickin'
We're just like the clock on the wall

WILBUR
Yeah our springs never pop

EDNA
And on the day that you drop

WILBUR & EDNA
Whoo! I'll catch you when you fall

And we got a kid
Who's done what she did
And we're as proud as proud can be

WILBUR
You're still my big affair

EDNA
Mein Herr!

WILBUR & EDNA
You're timeless to me

EDNA
You're rounding third base now

WILBUR
Holy cow!
You're timeless to me

EDNA
I'll always call you home

WILBUR
Shabbat Shalom!

WILBUR & EDNA
You're timeless to me
You're timeless to me
You're timeless to me
You're timeless to me!!!

(*End of Scene Two*)

SCENE THREE
TRACY'S JAIL CELL & PENNY'S BEDROOM

(**TRACY'S** *jail cell. Late at night.* **LINK** *slips in stealthily.*)

LINK: Tracy? Where are you? It's me. Link Larkin. From the show.

TRACY: Link! Over here!

LINK: Shhh! The guard's asleep. Gee, you look beautiful behind bars.

TRACY: It must be the low-watt, institutional lighting. Link, what are you doing here?

LINK: Oh, Tracy, seeing you dragged off to jail brought me back to my senses. I thought I'd lose it when I thought I lost you. I couldn't eat, I couldn't sing. I couldn't even concentrate.

TRACY: You couldn't eat?

LINK: No. So I went down to the station to tell Mrs. Von Tussle I was through with the Miss Hairspray broadcast...

TRACY: You did?

LINK: I didn't. When I got to the station I overheard Mrs. Von Tussle talking to Spritzer. Tracy, it's Amber the talent scouts are coming to see. It had nothing to do with me. All this time I thought Amber and I were a team. She and her mother were just using me to make her look popular. I feel like such an idiot.

TRACY: That makes two of us.

LINK: (*suddenly romantic*) I know a palooka like me isn't worthy of a ground-breaking extremist like you, but...

(*He produces his ring.*)

...It's a little scuffed from Amber throwing it in my face when I told her I'd rather be with you.

TRACY: You did?

LINK: I did. So, would you consider wearing my ring?

TRACY: Would I? Would I?

LINK: "To lose thee were to lose myself." Some kid named Milton wrote that in the third-floor boys' room.

TRACY: It's beautiful.

(*She puts on the ring.*)

I have a good life: great parents, my own room, stacks of 45s, three sweaters, plus a learner's permit good through August. But you know what I've been missing, Link?

LINK: I think I do.

(*They try to kiss.*)

Trace, they can keep us from kissing, but they can't stop us from singing.

"Without Love"

LINK
Once I was a selfish fool
Who never understood
I never looked inside myself
Though on the outside, I looked good!

Then we met, and you made me
The man I am today
Tracy, I'm in love with you
No matter what you weigh.

O'Donnell, Meehan, Shaiman, and Wittman

LINK (continued)
'Cause without love
Life's the seasons
With no summer

Without love
Life is rock 'n' roll without
 a drummer

Tracy, I'll be yours forever
'Cause I never wanna be
Without love
So Tracy, never set me free

No, I ain't lyin'
Never set me free, Tracy
No, no, no!

TRACY
Once I was a simple girl
Then stardom came to me
But I was still a nothing
Though a thousand fans
 may disagree
Fame was just a prison
Signing autographs a bore
I didn't have a clue
Till you came banging on my door

That without love
Life is like my dad without
 his bromo
Without love
Life's just making out to
 Perry Como

Darling, I'll be yours forever
'Cause I never wanna be
Without love

BACKUP
Without love

Ooh-ooh

Without love
Ooh-ooh-ooh

I'll be yours forever

Without love
...Doot

Doot do doot do
Doot do doot do
No, no, no!

Aah
Aah
Aah-aah
Aah-aah

Tracy!

...Without love
Ooh-ooh

Without love
Ooh-ooh-ooh

I'll be yours forever

Without love

Tracy (continued)
So darling, throw away the key

Link & Tracy	**Backup** (continued)
I'm yours forever	Doot doot do doot
	Doot doot doot
Tracy	
Throw away the key	Doot doo doot doot
Link & Tracy	
Yeah, yeah, yeah!	Yeah, yeah, yeah!

(The lights dim on the jail and brighten on **Penny's** *bedroom.* **Prudy** *is tying* **Penny** *to the bed.)*

Prudy: Penny Lou Pingleton, you are absolutely, positively, permanently punished. This one's for being willful. This one's for being deceitful. This one's for being neglectful. And this one's for crying "Wee wee wee," all the way home.

(The phone rings.)

Why is it every time you tie your daughter up, the phone rings?

*(***Prudy*** exits just as* **Seaweed** *appears in the window.)*

Seaweed: Psst! Penny!

Penny: Seaweed! Shhh! Don't let my mother hear you.

Seaweed: What happened?

Penny: She's punishing me for going to jail without her permission.

Seaweed: I've come to rescue the fair maiden from her tower.

Penny: Oh, Seaweed, you do care! I was worried it was just a lonely teenager's forbidden fantasy.

Seaweed: From the first moment I saw you, I knew that even the colors of our skin couldn't keep us apart.

O'Donnell, Meehan, Shaiman, and Wittman

(struggling with the rope)

But, damn, these knots are something else.

PENNY: Hurry, Seaweed!

SEAWEED
Living in the ghetto
Black is everywhere ya go
Who'd've thought I'd love a girl
With skin as white as winter's snow

PENNY
In my ivory tower
Life was just a Hostess snack
But now I've tasted chocolate
And I'm never going back

*(*SEAWEED* sets *PENNY* free.)*

PENNY & SEAWEED	**BACKUP**
'Cause without love	…Without love

SEAWEED	
Life is like a beat that you can't follow	Ooh-ooh

PENNY & SEAWEED	
Without love	Without love

PENNY	
Life is Doris Day at the Apollo	Ooh-ooh

PENNY & SEAWEED	
Darling, I'll be yours forever	I'll be yours forever
'Cause I never wanna be	
Without love	Without love

SEAWEED
Darling, never set me free

SEAWEED & PENNY
I'm yours forever
Never set me free
No, no, no!

BACKUP (continued)
Doot doot doo doot
Doot doot doo doot
No, no, no!

(*The light comes on in the jail again. From now on we can see both couples at once.*)

LINK
If you're locked up in this
 prison, Trace

Ooh-ooh

I don't know what I'll do

Ooh-ooh

TRACY
Link, I've got to break out

Ooh-ooh

So that I can get my hands on you

I can get my hands on you

SEAWEED
Girl, if I can't touch you now

Ooh, ooh, ooh, ooh

I'm gonna lose control

Lose control

PENNY
Seaweed, you're my
 black white knight

Black white knight

I've found my blue-eyed soul

SEAWEED
Sweet freedom is our goal

Sweet freedom is our goal

LINK
Trace, I wanna kiss ya!

TRACY
Then I can't wait for parole...

Oh Link, I've got to get out of here. If we only had some hair-spray and a Zippo lighter, I think we could make an E-Z Bake Oven kind of blowtorch!

LINK: Well, I've got a Zippo lighter! And, uh...

> (*embarrassed*)

I've got some hairspray too.

> (*He produces it from his jacket*)

TRACY: Link, what a special night! Your ring! And our very own blowtorch!

> (*As the number continues,* **LINK** *torches the cell bars to make a large* **TRACY***-shaped opening through which she escapes.*)

LINK: Oh, Tracy!

TRACY: Oh, Link!

PENNY: Oh, Seaweed!

SEAWEED: Oh, Penny!

PRUDY: (*enters and sees* **SEAWEED** *and* **PENNY** *on the bed*) Oh my God! Colored people in the house. I'll never sell it now!

ALL
'Cause without love

SEAWEED	**BACKUP**
Life is like a prom that won't invite us	Ooh-ooh

ALL
Without love

LINK	
Like getting my big break and laryngitis	Ooh-ooh

ALL
Without love

PENNY
Life's a 45 when you can't buy it

BACKUP (continued)
Ooh-ooh

ALL
Without love

TRACY
Life is like my mother on a diet

Ooh-ooh-ooh

ALL
Like a week that's only Mondays
Only ice cream never sundaes
Like a circle with no center
Like a door marked "Do not enter!"
Darling, I'll be yours forever
'Cause I never wanna be
Without love

PENNY & LINK
Yes now you've captured me

Without love

SEAWEED & TRACY
I surrender happily

Without love—ooh

LINK
So darling

ALL
Never set me free

Doot doot doot doot
Doot doot doot doot

ALL
Darling, you had best believe me
Never leave me without love!

(End of Scene Three.)

O'Donnell, Meehan, Shaiman, and Wittman

SCENE FOUR
MOTORMOUTH'S INSPIRATION

(*As the scene shifts we hear the sounds of sirens and helicopters and thunder and rain.* **MOTORMOUTH** *gazes out the window.* **LORRAINE**, **DUANE**, **GILBERT**, *and* **CINDY** *are watching the TV with rapt attention.*)

MOTORMOUTH: It's a mess out there.

CINDY: Good night for a jailbreak.

LORRAINE: Ms. Motormouth, look! Now it's on channel two!

(*She turns up the sound on the television…*)

NEWSCASTER (v.o.)**:** …Elsewhere in local news, teenage TV personality and rabble rouser, Tracy Turnblad, has escaped from the Baltimore Women's House of Detention. Authorities believe she may have been aided by the once promising, formerly wholesome teen idol, Link Larkin. If sighted, citizens are asked to notify police or, if phone service is not available, simply shoot to kill. In entertainment news, Eva Marie is no saint…

MOTORMOUTH: (*switching off the TV*) Lord have pity, it's a crazy city.

(*sound of a door slamming*)

Who's at the backdoor?

(**SEAWEED** *enters with* **PENNY**.)

MOTORMOUTH: My baby. And… Penny, is it?

PENNY: Yes, ma'am.

LITTLE INEZ: Seaweed's got a girlfriend.

SEAWEED: Is it okay I brought her home? I had to get her away from her nasty ass mama.

MOTORMOUTH: Hush, now. Don't explain. I got an inklin' in a twinklin' first time I seen you two dancing together.

PENNY: And you don't mind?

MOTORMOUTH: I never mind love. It's a gift from above. But not everyone remembers that. So you two better brace yourselves for a whole lot of ugly comin' at you from a never-ending parade of stupid.

PENNY: That's okay. My mother's gonna kill me anyway.

(*There is a knock at the door.*)

LITTLE INEZ: No she won't. She'll kill him!

LINK: (*entering with* **TRACY**) Hey, Miz Motormouth. We broke Tracy out of jail.

GILBERT: We know. It's been on all three channels!

TRACY: The jailbreak was easy compared to getting a cab to this side of town.

MOTORMOUTH: Well, we all gotta get busy. Only twenty-four hours till Miss Hairspray, and it's gonna be on national TV. We may never get another chance like this. And this time we'll start by getting Corny and the guards at the studio to help us.

PENNY: Maybe your Dad could help, too. He sometimes has ideas.

SEAWEED: And I know a guy who…

TRACY: (*interrupting* **SEAWEED**) No, I've got to turn myself in and go back to jail.

LITTLE INEZ: Say what?

LINK: Tracy, no.

TRACY: I can't put all of you in any more danger. We should've thought more before we broke out. My father could lose the Har-De-Har Hut. And, Link, you could go to prison for what you did tonight…

LINK: (*pleading innocence*) Just first base in the back of the cab. I swear.

TRACY: …And Ms. Motormouth, we've just been on three channels of news; I don't want you to get arrested for harboring a fugitive. And, Penny… your mother will kill you!

LITTLE INEZ: (*impatiently correcting again*) No! She'll kill *him*!

LORRAINE: Listen, I've already been to jail one time for backing up the white girl. Don't mind sittin' this round out!

DUANE: I hear you. Besides, we already tried it and it didn't work.

TRACY: Anyway, this time it won't be like Mother-Daughter Day. Mrs. Von Tussle said there'll be armed guards at the Eventorium.

PENNY: With arms.

TRACY: Someone could get shot.

GILBERT: And for what? Just so we can dance on some Oh-fay show?

MOTORMOUTH: Hold it! Nobody ever said this was gonna be easy. If something's worth having, it's worth fighting for. Tracy, why did you start all this in the first place? Was it just to dance on TV?

TRACY: No.

MOTORMOUTH: Was it so you could get the boy?

TRACY: No, I almost lost him because of it.

MOTORMOUTH: Then maybe it was just to get yourself famous.

TRACY: (*taking exception, slightly*) No. I just think it's stupid we can't all dance together.

MOTORMOUTH: So you tried once and you failed. We can't get lazy when things get crazy. Children, you were not the first to try and you won't be the last, but I am here to tell you that I'm gonna keep lining up until someday somebody breaks through. And I've been looking at that door a lot longer than you.

TRACY: What door?

MOTORMOUTH: The front door.

"I Know Where I've Been"

MOTORMOUTH
There's a light in the darkness
Though the night is black as my skin
There's a light burning bright
Showing me the way
But I know where I've been

There's a cry in the distance
It's a voice that comes from deep within
There's a cry asking why
I pray the answer's up ahead
'Cause I know where I've been

	BACKUP
There's a road we've been travelin'	Oo-oo
Lost so many on the way	Oo-oo
But the riches will be plenty	Oo-oo
Worth the price we had to pay	Oo-o

There's a dream in the future	...Dream, Oo-oo
There's a struggle we have yet to win	
And there's pride in my heart	Hoo-oo

O'Donnell, Meehan, Shaiman, and Wittman

MOTORMOUTH (continued)
'Cause I know where I'm going
And I know where I've been

There's a road we must travel
There's a promise we must
 make
'Cause the riches will be
 plenty

Worth the risk and the
 chances
That we take

There's a dream in the future
There's a struggle

We have yet to win
Use that pride

In our hearts

To lift us to tomorrow
'Cause just to sit still would be a sin

Lord knows
I know where I've been

I'll give my thanks to God
'Cause I know where I've been

BACKUP (continued)
Hoo-oo-oo-oo

There's a road we must travel
There's a promise we must
 make
'Cause the riches will be
 plenty

Worth the risk and the
 chances
That we take

…Dream, hoo-oo-oo

Struggle
Hoo-oo-oo

Pride

In our hearts
Lift us up
Oo-oo-oo-oo
Ooh… sit still
I know it, I know it
I know where I'm goin'

Oh, when we win
I'll give thanks to my God
'Cause I know where I've
 been

(Song ends. End of Scene Four.)

SCENE FIVE
MISS TEENAGE HAIRSPRAY

(The Baltimore Eventorium. Lights and music herald The Corny Collins Spectacular. A Miss Teenage Hairspray 1962 scoreboard shows AMBER *leading* TRACY *by a few votes. Drum roll…* CORNY *appears on stage.)*

CORNY: *(music)* And now, live, from the certified up-to-code Baltimore Eventorium… for the first time ever on nationwide television… it's The Corny Collins Spectacular…

COUNCIL MEMBERS: He's Corny!

CORNY: …brought to you by Ultra Clutch Hairspray!

"(It's) Hairspray"

CORNY
What gives a girl
Power and punch?
Is it charm, is it poise? **BACKUP**
No, it's hairspray! …Hairspray!

What gets a gal
Asked out to lunch
Is it brains, is it dough?
No, it's hairspray! …Hairspray!

If you take a ride Ooh
With no can at your side Oo-oo-ooh-ooh
Then your flip will be gone with Then your flip
 the wind Ooh-ooh-ooh!

But if you spray it and lock it,
You can take off in a rocket You can take off in a rocket
And in outer space …Outer space
Each hair will be in place Hair will be in place

CORNY (continued)
Why take a chance
When you get up and dance
If you twist, I insist
You use hairspray

And tell your mother
Her head she should smother
With Ultra Clutch faithfully

BACKUP (continued)
Ooh, ooh
Ooh, oo-oo-ooh
Ooh
…Hairspray!

Ooh
Ooh, Ooh
Ultra Clutch faithfully

ALL
So if you're a redhead, a blonde, or brunette—woo!

CORNY
Just take my advice
And you might just get

The only thing better than hairspray
That's me!

You might just
Ooh, ooh… Hairspray

Ska-doo-dl-e-ya
Doo-dl-e-ya do wah

Forget the milkman
The only thing better than hairspray

Hairspray wow

CORNY
That's me!

COUNCIL MEMBERS
Ah, ah, ah, ah, ah, ah, ah, ah, ah
Ah, ah, ah, ah, ah, ah, ah, ah, ah

CORNY & COUNCIL MEMBERS
What makes a man
Reach out and touch
Ultra Clutch!

ALL
So if you're a redhead, a blonde, or brunette

O'Donnell, Meehan, Shaiman, and Wittman

CORNY
Just take my advice
And you might just get

The only thing better than hairspray
That's me!

GIRLS
He's Corny Collins!

CORNY
The only thing better than hairspray

That's me!

CORNY & THE COUNCILETTES
Ska-doo-dl-e-ya-do-wah
Ska-doo-dl-e-doo-wah-do-wah

BACKUP (continued)
You might just
Ooh, ooh… Hairspray

Ska-doo-dl-e-ya
Doo-dl-e-ya do wah

Hairspray wow!

CORNY: "Hey baby, you look like you could use a stiff one!"

BRENDA
Ska-doo-dle-doo-do-wah!

> (*Applause. A* **MAN** *in a hat and a fake nose enters pushing a gigantic hairspray can.* **VELMA** *approaches suspiciously.*)

VELMA: And we're off for network commercial. What the hell is this?

MAN (WILBUR): Product placement. The sponsor insists.

VELMA: What a relief. We needed a little something there.

> (*suddenly shifting*)

Say, don't I know you?

WILBUR: Honest, Velma, I'm a total stranger.

(**VELMA** *whips off his hat and funny glasses to reveal* **WILBUR**.)

VELMA: You!

WILBUR: Damn!

VELMA: (*calling for back-up*) Guards! Riot squad! I want everybody out of the lobby and up here pronto.

> (**SEAWEED** *and three* **MOTORMOUTH BOYS** *dressed as* **GUARDS** *run in from the aisle.*)

Ha! What is this? Some kind of Trojan Horse? What's inside, your jailbird daughter?

WILBUR: Not a chance.

VELMA: Well, if she's hiding in that can, she'll rot in that can. Guard, if anybody so much as touches that thing… open fire!

MOTORMOUTH: (*dressed as a guard wearing a riot helmet*) Understood, Ma'am.

> (**MOTORMOUTH** *pulls* **WILBUR** *off.*)

WILBUR: You win this time, Von Tussle. You're one clever woman, I'll say that.

VELMA: (*to* **SEAWEED**) Get out!

> (**SEAWEED** *exits up the theatre aisle.*)

And coming back to Corny on camera one in 3… 2…

CORNY: And now for the talent portion of the competition where the frontrunner gals present a dance of their own creation.

(looking at the scoreboard)

Presently, Amber Von Tussle and Tracy Turnblad are neck and neck. But since, according to the latest police bulletins, Miss Turnblad is still at large…

AMBER: (*leaning into the shot*) At *very* large.

CORNY: …our Miss Hairspray might just be a foregone conclusion. Still, our rules say the contestant has to dance for it. Ready, Amber?

AMBER: Ready as a rabbit on Easter, Corny. Tracy Turnblad, this song is all about you.

"Cooties"

AMBER
They came from way far out
In outer space
She's hard to miss
And so they landed on her face!

COUNCIL MEMBERS
Ow-oot

GUYS
She's got cooties

GIRLS
Cooties

AMBER
They've found a place to nest

GUYS
She's got cooties

GIRLS
Cooties

AMBER
If I were her I'd be depressed
Long tailed, sharp nailed
Fuzzy legs, laying eggs

C'mon everybody, let's stamp them out!!

COUNCIL MEMBERS
She's got cooties

AMBER
In science class
She's like a walking show-and-tell

COUNCIL MEMBERS
She's got cooties

AMBER
You know she's coming down the hall
From just the smell!

GUYS	**GIRLS**
She's got cooties	Cooties

AMBER
Nobody wants to sit by her

GUYS	**GIRLS**
She's got cooties	Cooties

AMBER
Don't need a coat 'cause she's got fur!
Circle, circle
Dot, dot, dot

ALL
Hurry, get your cootie shot!

AMBER
Dresses like a circus clown

COUNCIL MEMBERS
Somebody oughta hose her down

AMBER
Grew up in a cootie zoo
I bet her two-ton mama's got 'em too!

"And that's for you!"

O'Donnell, Meehan, Shaiman, and Wittman

Thank you ladies, gentlemen, and kids. I'm now ready to consume the title of Miss Teenage Hairspray.

(**Corny** *leads* **Spritzer** *on.* **Spritzer** *carries the crown and bouquet.*)

Corny: Just to be sure, I think we'd better check the board.

Spritzer: Could we please see the tally?

(**All** *turn to the scoreboard. The numbers spin and* **Amber** *is the winner by a few votes.*)

Spritzer: Yes, Amber Von Tussle just squeaks in as the winner.

Amber: What'd I tell you? Give me the crown, give me the flowers, and everybody start bowing!

(**Amber** *snatches the crown and slaps it onto her head.* **Velma** *puts the Miss Teenage Hairspray 1962 sash on* **Amber.**)

Tracy: (*from the theatre aisle*) Not so fast, Amber. Look who's coming in the front door.

(*an explosion of music and light*)

Corny: Right on schedule! I mean, I know nothing about this complex plan. Ladies and gentlemen, I give you the never to be counted out Tracy Turnblad!

(*A spotlight picks up* **Tracy** *as she makes her way up the aisle, singing, dancing, and celebrating. She is followed by* **Link, Penny, Seaweed,** *the* **black female ensemble,** *and* **Little Inez.**)

"You Can't Stop the Beat" (part 1)

Tracy
You can't stop an avalanche
As it races down the hill
You can try to stop the seasons, girl
But 'cha know you never will

TRACY (continued)
And you can try to stop my dancin' feet
But I just cannot stand still

'Cause the world keeps spinning
'Round and 'round
And my heart's keeping time
To the speed of sound
I was lost till I heard the drums
Then I found my way

TRACY & LINK
'Cause you can't stop the beat

Ever since this old world began
A woman found out if she shook it
She could shake up a man
And so I'm gonna shake and shimmy it
The best that I can today

'Cause you can't stop
The motion of the ocean
Or the sun in the sky
You can wonder if you wanna
But I never ask why

And if you try to hold me down
I'm gonna spit in your eye and say
That you can't stop the beat!

What d'ya say, Penny?

(**PENNY** *appears. She is totally restyled cool! The remaining* **BLACK DANCERS** *escort her.*)

PENNY
I am now a checkerboard chick!

| You can't stop a river | **BACKUP** |
| As it rushes to the sea | Ooh-ooh |

O'Donnell, Meehan, Shaiman, and Wittman

PENNY (continued)
You can try and stop the hands of time
But 'cha know it just won't be
And if they try to stop us, Seaweed
I'll call the NAACP!

'Cause the world keeps spinning
'Round and 'round

SEAWEED
'Round and 'round

And my heart's keeping time
To the speed of sound

Speed of sound

I was lost till I heard the drums
Then I found my way

PENNY, SEAWEED, TRACY, & LINK
'Cause you can't stop the beat

Ever since we first saw the light
A man and woman liked to shake it
On a Saturday night
And so I'm gonna shake and shimmy it
With all my might today-ay-ay-ay

'Cause you can't stop
The motion of the ocean
Or the rain from above
They can try to stop the paradise
We're dreaming of
But they cannot stop the rhythm
Of two hearts in love to stay
'Cause you can't stop the beat!

> (*The* ARMED GUARDS *begin to turn around to reveal themselves to be the* BLACK MALE ENSEMBLE.)

TRACY: Get her!

> (*The* BLACK MALE ENSEMBLE *carry* VELMA *off.*)

Amber, this is my dance, and it's dedicated to everybody!

(**Tracy**, **Link**, **Seaweed**, **Penny**, *and the* **black kids** *dance their asses off, then pull the* **council members** *in until all the* **kids** *are dancing together! All, that is, except* **Amber**, *who has taken the crown and sash and defiantly has taken possession of the throne.*)

All
Ever since we first saw the light
A man and woman liked to shake it
On a Saturday night
And so I'm gonna shake and shimmy it
With all my might today

'Cause you can't stop
The motion of the ocean
Or the rain from above
They can try to stop the paradise
We're dreaming of
But they cannot stop the rhythm
Of two hearts in love to stay
'Cause you can't stop the beat!
You can't stop the beat!!
You can't stop the beat!!!

Tracy!

(*triumphant applause*)

Corny: Everyone, look… Look at the scoreboard!

(**All** *turn to see the scoreboard spontaneously combusting, showing* **Tracy** *is the overwhelming winner.*)

Tracy Turnblad, I declare you Miss Teenage Hairspray 1962!

Velma & Amber: *No!*

Amber: It's wrong! It's just so wrong!

Little Inez: (*to* **Amber**) Hand over that halo, honey.

Amber: You'll have to rip it from my cold, dead hands.

Little Inez: That'll work.

Tracy: You can keep your stupid crown, Amber. I have my heart set on something a lot more important.

Link: Would that happen to be… me?

Tracy: Of course you, Link. But I also want a graduate degree in musicology with a minor in ethnic studies. And I want to be the first one to say, *The Corny Collins Show* is now and forevermore officially integrated!

 (*A cheer fills the Eventorium.*)

Corny: America look up! Here's history right before your eyes. Television will never be the same.

Spritzer: (*entering ecstatic, takes the microphone from* **Corny**) This is marvelous. The phones are going crazy. The whole country's watching. Even the governor called. He's enjoying the show so much that he's granted a pardon to Tracy, plus a full scholarship to Essex Community College! You cannot buy this kind of publicity. Velma, you are a genius!

Velma: I am? Yes, I am.

Spritzer: Ultra Clutch is about to launch an entirely new line of products, and I want this woman to head the campaign.

Velma: (*curiously*) I just don't know what to say.

Spritzer: It comes with offices, a company car, and a multi-figured salary.

Velma: (*hopefully*) I just don't know what to say.

Spritzer: Velma Von Tussle, you are the newly appointed vice president of Ultra Glow, beauty products for women of color!

Velma: (*stupified*) I just don't know what to say!

SPRITZER: (*to* **LINK** *and* **TRACY**) And America would like to hear you two kids sing our new theme song. I think I can get you a recording contract.

LINK: My big break!

> (*The happiness is shattered with a scream as* **PRUDY** *runs down the aisle…*)

PRUDY: Give me back my daughter! I know you've got her. I saw it on TV.

> (**PENNY** *stops and faces* **PRUDY**. **SEAWEED** *stands protectively by.*)

Penny. I hardly recognize you done up like that.

PENNY: I'm a pretty girl, Mama.

PRUDY: And you look so happy. I can't say it's what I want, but if this fine looking, catlike black boy is responsible for the light in your eyes, then how could I object?

> (**PRUDY** *and* **PENNY** *embrace*. **SEAWEED** *embraces* **PRUDY**.)

CORNY: Live television—there's nothing like it.

LINK: This may not be the right moment since we're on national TV and all, but Tracy, if I don't kiss you now, I just may bust a gut.

TRACY: Well, I certainly wouldn't want you to hurt yourself.

> (*They kiss.*)

WILBUR: That's my girl!

VELMA: Before I get completely sick, would somebody tell me this —If she came in through the front door… what the hell is in that can?

WILBUR: My masterpiece. Seaweed, would you give me a hand?

SEAWEED: Comin' right up, Mr. T!

(**Seaweed** *climbs the giant hairspray can, ready to trigger it.*)

Wilbur: This could be the largest novelty item ever erected. Fire!

(**Seaweed** *pushes the nozzle, and the hairspray can explodes in smoke and glitter to reveal* **Edna** *dressed in finery.*)

Edna: So, what'd I miss? I've been stuck in that can since lunch. And I wouldn't rush right in there after me if I was you.

Tracy: Mama, we did it! We're on national TV.

Edna: National television? America, I made this myself!

"You Can't Stop the Beat" (part 2)

Edna
You can't stop my happiness
'Cause I like the way I am
And you just can't stop my knife and fork
When I see a Christmas ham
So if you don't like the way I look
Well, I just don't give a damn!

	Backup
'Cause the world keeps spinning	Keeps spinning
'Round and 'round	'Round and 'round
And my heart's keeping time	Keeping time
To the speed of sound	To the speed of sound
I was lost till I heard the drums	Till I heard the drums
Then I found my way	Then I found my way

All
'Cause you can't stop the beat
Ever since this old world began
A woman found out if she shook it
She could shake up a man
And so I'm gonna shake and shimmy it
The best that I can today

ALL (continued)
'Cause you can't stop
The motion of the ocean
Or the sun in the sky
You can wonder if you wanna
But I never ask why

And if you try to hold me down
I'm gonna spit in your eye and say
That you can't stop the beat!

EDNA: Wilbur, be a dear and call for backup... *Now!*

(*Now* **MOTORMOUTH** *steps forward and removes her riot helmet.*)

WILBUR: Officer! Assistance please!

MOTORMOUTH
Step aside, Miss Buttercup... it's time to wrap this mutha up!

Oh, oh, oh,
You can't stop today

 BACKUP (continued)
 No!

As it comes speeding down the track

 Oo-oo-oo child yes

Child, yesterday is hist'ry

 Be gone

And it's never coming back

 Look ahead
'Cause tomorrow is a brand-new day 'Cause tomorrow...
 ...Brand-new day

And it don't know white from black

 Yeah!
'Cause the world keeps spinning Keeps spinning
'Round and 'round 'Round and 'round
And my heart's keeping time Keeping time
To the speed of sound To the speed of sound

MOTORMOUTH (continued)
I was lost till I heard the drums
Then I found my way
'Cause you can't stop the beat

BACKUP (continued)
Till I heard the drums
Then I found my way

ALL
Ever since we first saw the light
A man and woman liked to shake it
On a Saturday night
And so I'm gonna shake and shimmy it
With all my might today-ay-ay-ay

'Cause you can't stop
The motion of the ocean
Or the rain from above
They can try to stop the paradise
We're dreaming of
But they cannot stop the rhythm
Of two hearts in love to stay
'Cause you can't stop the beat!

> (**VELMA** *is by* **AMBER'S** *side. They are defeated and
> confused until the* **ENSEMBLE** *focus on them…*)

Aah, aah, aah
Aah, aah, aah
Aah, aah, aah
Come on you Von Tussles
Go on and shake your fanny muscles

VELMA & AMBER
We can't!

ALL
Yes, you can!

VELMA & AMBER
No, we can't!

ALL
Yes, you can!

VELMA & AMBER
Yes, we can...!!!

ALL
You can't stop the beat

VELMA & AMBER	**BACKUP**
Ever since we first saw the sun	Ooh-ooh
It seems Von Tussle girls are always	
Tryin' to please someone	Ooh-ooh
But now we're gonna	
Shake and shimmy it	Ooh-ooh
And have some fun today	...Today

ALL
'Cause you can't stop
The motion of the ocean
Or the rain from above
They can try to stop the paradise
We're dreaming of
But they cannot stop the rhythm
Of two hearts in love to stay
'Cause you can't stop the beat!
You can't stop the beat!!
You can't stop the beat!!!

(Curtain)
(End of Show)

　　　　　O'Donnell, Meehan, Shaiman, and Wittman